The Zeon Files

THE

ZEON

FILES

Art and Design of Historic Route 66 Signs

UNIVERSITY OF NEW MEXICO PRESS | ALBUQUERQUE

Mark C. Childs

and

Ellen D. Babcock

Support for publication of this book was provided in part by
the Urban Enhancement Trust Fund, City of Albuquerque.

Library of Congress Cataloging-in-Publication Data
Names: Childs, Mark C., 1959– | Babcock, Ellen D., 1957–
Title: The Zeon files : art and design of historic Route 66
signs / Mark C. Childs and Ellen D. Babcock.
Description: Albuquerque : University of New Mexico Press,
2016. | Includes bibliographical references.
Identifiers: LCCN 2015029048 | ISBN 9780826356024
(pbk. : alk. paper) | ISBN 9780826356031 (electronic)
Subjects: LCSH: Roads—United States—History. |
United States Highway 66—History. | Roads—Design and
construction—United States. | Signs and signboards.
Classification: LCC HE355.C5295 2016 |
DDC 659.13/42—dc23
LC record available at http://lccn.loc.gov/2015029048

Cover art: drawings courtesy of the Center for Southwest
Research; photograph courtesy of Mark C. Childs
Designed by Lila Sanchez
Composed in Sabon, Univers, and Callie Hand

This book is dedicated to the memory
of Dave Specter and J. Wilbur Jones,
partners and founders of Zeon Signs.
They made the night a little brighter.

2017

Merry
Christmas, Dad!
I tracked this book down after
first reading about it in an article
last year — one of the authors rescued boxes
of original design files. They had been haphazardly
placed outside after the Fire Marshall declared
them a hazard! I love the peek at the design + engineering
in this book, and at the jobs + people it took to create
these signs. I haven't been able to re-find the original article, but this
one gives a brief of the story:
http://news.unm.edu/news/the-zeon-files-sheds-neon-light

Love you! ♡
-N.

Contents

Acknowledgments

We thank the owners and employees of Zeon Corporation, Sherri Brueggemann, Paul Secord, Noreen Richards, University of New Mexico Center for Southwest Research, Albuquerque Museum Photoarchives, and all the citizens of Albuquerque who told us your stories.

Support for publication of this book was provided by the Urban Enhancement Trust Fund, City of Albuquerque; and Judith Greenfeld, Lionel Specter, Nadine Plath, and James W. Jones.

A NOTE ON THE IMAGES

All images cited with a file number such as "a14988" are from the Zeon Sign Company records, MSS 927 held at the Center for Southwest Research, University Libraries, University of New Mexico, and were originally the business files of Electrical Products of New Mexico.

AREA
900'

7.5 × 12 =
3×5=15= $\dfrac{15 \times \pi}{9}$ = 1.750'

$\dfrac{1020'}{30}$
$\dfrac{3060}{}$

MA
× 19 = 132
× 1.25 = $\dfrac{1842}{30}$

M
1710

$2\overline{)55.260}$ (27.63*

14'-9"

8"
STD

ONE | *The Great Neon Way*

PAINTED METAL SHIELD.
NO ILLUMINATION

speed display

TELESCOPED PIPES CHARCOAL
GREY WITH RED PAINTED RINGS

Gas Valve here
so gasteriches can be
turned down in daytime.

Eddie's Inferno Cocktail Lounge (fig. 2.24), Star Florist (fig. 2.13), Bunny Bread (fig. 2.44), Paris Shoe Shop (fig. 2.30), and many other businesses throughout mid-twentieth-century Albuquerque, New Mexico, and the surrounding Southwest had fanciful roadside signs designed and installed by Zeon Signs (officially, the business was called Electrical Products of New Mexico). *The Zeon Files* presents and discusses a historic collection of working drawings from 1956 to 1970 for these late Route 66–era signs.

These drawings are artworks in themselves and should be celebrated for their purposeful playfulness, but they are also rich examples for artists, sign designers, cultural and urban historians, Route 66 aficionados, and urban designers. The spirit of delight embodied in these signs can serve to inspire new artworks and signs and perhaps prompt improvement in the design of other everyday aspects of our built landscape. Could our cell-phone towers, power lines, and sidewalks be more vibrant and integrated into the overall character of our main streets?

Electrical Products of New Mexico was established in Albuquerque in 1939. With the diversion of materials to the war effort, the company shut down in 1941. They reopened in 1949 and as of 2015 continue to operate on Fifth Street in Albuquerque.

3

The company is currently owned by four partners, two of whom are sons of original founders and technicians. The company's history is evident throughout their building complex, from dusty bins of vintage plastic alphabet signs and stacked rolls of vellum to scaling-up grids for lettering hand-painted on the walls. The sign company adopted its colloquial name, Zeon, from a now-defunct corporation of the 1950s that tested components of neon signs as a kind of underwriters' lab—if a business conformed to the Zeon Corporation's specifications, the proprietary name could be used as a hallmark of quality.

The drawings of this collection are to the best of our knowledge the work of Ralph Johnson, Keith Kent, and Carl Stehwein. Coauthor Ellen D. Babcock, an artist interested in the potential to install public artwork on unused road signs in Albuquerque, discovered multiple file drawers of project records on pallets outside the old Zeon building, placed there in an exasperated and hasty attempt to appease the fire marshal. The bulky drawers contained hundreds of yellowing envelopes that served as the business records of the company from 1955 until the late 1970s. As well as storing correspondence with customers, dozens of these envelopes contained lovely, delicate, colored-pencil-on-vellum working sketches. As key records of a distinctive part of the Southwest's history, the files are now housed at the Center for Southwest Research at the University of New Mexico.

Zeon was, of course, one of many neon sign companies in Albuquerque and the Southwest. In 1955, 1960, and 1970, Hudspeth's Albuquerque City Directory lists five neon sign companies. Electrical Products Company (Zeon), Ace Neon Signs, and Smith's Neon Sign Service are the only three that existed throughout this period; others came and went. The 2015 Dex phone book lists three companies under "Neon," and Electrical Products Company (Zeon) is the only one left from the heyday.

These commercial art artifacts record the craftwork of sign design and construction, document characteristics of roadside imagery and the American "great neon way," serve as part of the narrative landscape of Route 66, and are themselves compelling aesthetic works that can inspire contemporary work.

CRAFTWORK

In his book *The Craftsman*, Richard Sennett (2008) characterizes *craft* as artisans using head and hands, mind and material in small workshops, and as a dedication to quality work for its own sake. This collection of working drawings documents aspects of the craft of commercial sign design.

Excellent draftsmanship is seen throughout the collection and was recognized by designer Keith Kent's first-place award for the Fiesta Lanes Bowling Alley sign in a national competition hosted by General Electric (fig. 1.1). The drawings exhibit well-rendered hand-drafting conventions and techniques such as the expert use of line weight to suggest three-dimensional form (see figs. 2.16, 2.62) and the location of notes and dimensions. Experimentation with and evolution of these conventions can be seen in the use of press-on letters (fig. 2.52), reflective tapes, and artwork stickers (fig. 2.44). Although most of the drawings are on vellum, heavy craft paper and other types of paper were also used (figs. 2.16, 2.48). Many of these drawings contained figures to provide a sense of scale. These scale figures are not part of the proposed sign and thus they often provided a vehicle for commentary and jokes (figs. 1.2, 1.3, 1.4).

Figure 1.1 Fiesta Bowling Alley Sign, 2014. The original design for the Fiesta Bowling Alley sign won a national design competition hosted by General Electric. The bowling alley has since closed but the sign was adapted for new businesses. Photograph by Mark C. Childs, 2014.

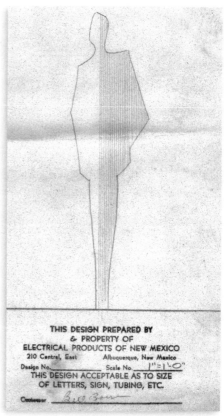

THIS DESIGN PREPARED BY
& PROPERTY OF
ELECTRICAL PRODUCTS OF NEW MEXICO
210 Central, East Albuquerque, New Mexico
Design No. _____ Scale No. 1"=1'-0"
THIS DESIGN ACCEPTABLE AS TO SIZE
OF LETTERS, SIGN, TUBING, ETC.

Customer _____

Figure 1.2 Scale figure 1. Scale figure from file a12909 with the Electrical Products of New Mexico stamp.

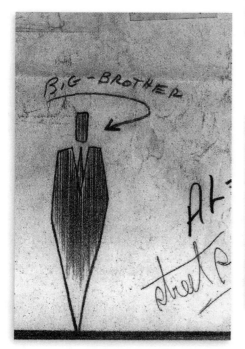

Figure 1.3 "Big brother" scale figure 2. Scale figure from file a14092 with commentary.

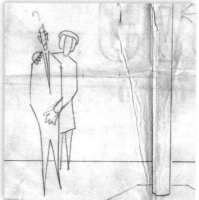

Figure 1.4 Scale figures 3. Scale figures from a14900 with graphic addition. This file was folded so that the image appeared on the outside.

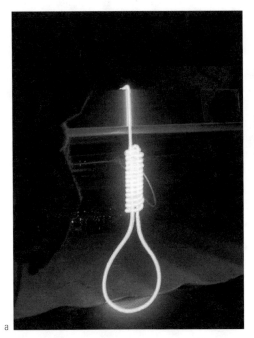

a

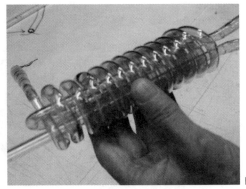

b

glass successfully. The noose photographed here is Jere's second. The first one disappeared from the shop one day while the workers were away at lunch. Apparently someone who had been admiring the extraordinary object had, the day before the disappearance, unsuccessfully tried to talk Jere into selling it (personal communication). Undaunted, the accomplished glassblower made another noose that, charged with electricity, glows a violent red. Photographs by Ellen D. Babcock.

Figures 1.5a and b Neon Noose. Jere Pelletier is proud of a neon noose he made at Zeon in his free time in the 1970s just to see if he could accomplish such a feat. It is an actual glass slipknot, coiled thirteen times, and it required an assistant to bend the

Figure 1.6 Central Avenue in downtown Albuquerque at night circa 1950. Photograph courtesy of Nancy Tucker.

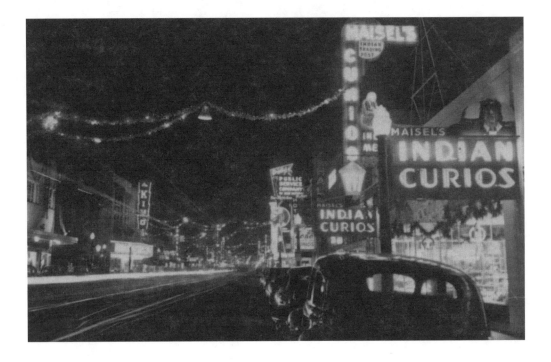

Of course, craftsmanship is seen not only in the means of illustration but also in the design of the signs. These working drawings document graphic expertise in the choice and layout of type, creation of "pictorial" lettering and new fonts, drawing of illustrations, and dynamic use of sculptural silhouette and apparent motion. Moreover, the skills of glassblowing, bulb filling and wiring, sign painting, metal working, wiring and balancing electrical systems, and construction are essential to the craft of neon sign making.

These files attest to a cohesive workshop in which design, construction, and installation are integrated. A note on the working drawing for Eddie's Inferno reads, "Turn up mouth to give slight smile" (fig. 2.24). The note illustrates a critical aspect of craft communications: rather than the precise instructions required by highly mechanized work, the note communicates the desired outcome to an artisan who is trusted to use his or her own skills and methods. The drawings were vehicles for designers to develop and prototype a project—to see, discuss, measure, and price the work. They provided a concrete means of communication between client and designer, designer and installer, and installer and building inspector. The layers of notes and changes on the drawings and the associated letters and permits of each file were the instruments of the dialogue.

Finally, the story of the neon noose testifies to the pride and joy of Zeon's craftspeople in their work. Jere Pelletier, an experienced glassblower for Zeon and the father of one of the current owners, created a neon noose that became legendary for its intricacy. This feat, which took an assistant and days, was undertaken not for a customer but solely to see if such a thing could be made (figs. 1.5a, b). Mid-twentieth-century sign making was clearly a craft.

THE RISE OF NEON

The first neon advertising sign was installed in 1912 on a barbershop in Paris. Neon signs are first recorded in the United States in 1923: "In the USA the new technology travelled from Los Angeles to the East. In 1923 a car dealer from Los Angeles purchased two neon signs in Paris. From then on, high above the streets of the Californian metropolis they proclaimed the Packard make of cars in orange letters" (Ribbat 2013, 35). The first neon sign in Albuquerque may have been installed for the 1927 Firestone building on Central Avenue near downtown. The earlier introduction of electric light in theaters and the establishment of "great white ways"—commercial streets lit by elaborate street advertisements, illuminated storefronts, and electric streetlamps—paved the way for the subsequent explosion of neon.

Among the first customers for electric lighting were theaters. For example, in 1883 the Edison Electric Light Company provided lighting effects for a Broadway theater that included chorus girls with lights flashing from their foreheads. In 1877 an employee of the Paris Opera produced a catalogue of electrical apparatus for sale to other theaters (Nye 1990, 30). This was followed by spectacular electric advertisements and theater marquees. In 1892 the first New York electric sign, "Ocean Breezes," appeared on the side of the Cumberland Hotel. Its six lines of type in different-colored, three-to-six-feet-tall letters blinked in sequence (Ephemeral New York 2013). By 1900 H. J. Heinz built a forty-five-foot-long pickle composed of green bulbs. The famous New Year's Eve ball drop began in Times Square in 1905. In 1910 "The Leaders of the World" sign (also known as the Roman chariot race sign) went up over Herald Square in New York. This seventy-two-foot-high by ninety-foot-wide

sign "created the illusion of galloping horses, straining drivers, furiously spinning chariot's wheels and snapping whips . . . giving viewers an illusion something like that provided by a motion picture camera" (Nye 1990, 52).

These signs were not limited to New York. The 1911 street front of the Butterfly Theater in Milwaukee, for example, featured an elaborately lit butterfly statue surrounded by an entire façade of lights (Treu 2012, 62). Soon after, electric signs blossomed across the country: "By 1910, Los Angeles boasted that almost one sign per day had been installed since the start of the Southern California Edison Company's electric sign campaign almost a year earlier" (Treu 2012, 51).

Also by 1910 electrical advertisements covered more than twenty blocks of Broadway (Nye 1990, 51). The term *great white way* used for this brightly lit commercial and entertainment street is attributed to a columnist for the *New York Morning Telegram* (Bloom 2003, 499). The term and the purposeful creation of such a street were appropriated by urban designers and town boosters across the United States (see fig. 1.6) (Nye 1990). Albuquerque wired its main street for lighting in 1883, three years after New York City (Childs 1996). The adoption of this technology was not just a change in engineering but rather a celebrated cultural event. For example, "the inauguration of each new White Way became a community event with speeches, a parade, and extensive newspaper coverage" (Nye 1990, 57).

This urban construct, a nightlife district with elaborate commercial lighting, was the perfect habitat for the neon sign. Neon (and its brethren noble gases) offered a range of colors, the potential for more compact signs, lower electric bills, less maintenance, and a sculptural quality unobtainable with pixels of incandescent bulbs.

The great era of neon bloomed in the late 1920s and '30s, flickered during World War II, and had a second flowering through the 1960s. By the late 1970s the cheaper, more durable, and easily changed backlit plastic signs crowded out neon. In places like Albuquerque this change was abetted by new sign ordinances that limited height, size, shape, and motion. A 1976 Albuquerque ordinance, for instance, caused the soaring sail-shaped sign of the Trade Winds Motel to be lopped to half-mast and most new sign design in the Central Avenue corridor to be limited to rectangular shapes. Certain signs such as the Zia Motor Lodge sign were grandfathered in and allowed to stay and now, although marooned in an empty lot, stand as tall, iconic vestiges of a booming era (see figs. 1.7, 1.8).

However, just as neon signs continued to utilize the earlier technology of fields of incandescent bulbs (see fig. 2.60), signs using both backlit plastic squares and neon were built (see fig. 2.61). As we debate the proper preservation, reuse, or revival of signage, it is important to note that there was never a time when only one technology was used. Moreover, many of the signs in this collection were remodels of earlier structures, and many were later adapted. Perhaps one of the key characteristics of Route 66 signage is its creative ferment.

In the twenty-first century a host of urban design efforts aimed at both historic preservation and economic development have initiated neo-neon districts. In 2008 Portland, Oregon, adopted the North Interstate Corridor Plan that includes a neon district (City of Portland 2008); the downtown association in Winnipeg, Manitoba, conducted a study on creating a neon district in 2010 (Bridgman Collaborative Architecture 2010); and in 2013 Albuquerque adopted a

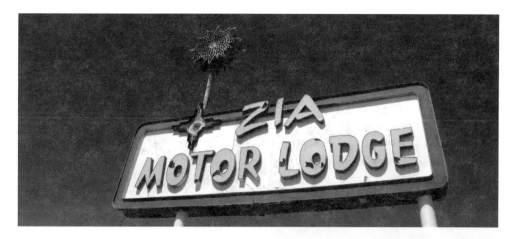

Figure 1.7 Grandfathered sign, Zia Motor Lodge, 2015. Photograph by Mark C. Childs.

Figure 1.8 Grandfathered sign, Premiere Hotel, 2015. This sign was recently refurbished. Photograph by Mark C. Childs.

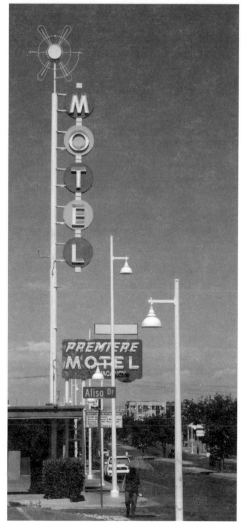

revision to the sign ordinance along the Central Avenue/Route 66 corridor to encourage lighted signage, and the City Public Art Urban Enhancement Program in the Cultural Services Department sponsored a neon artist program to support the design of new neon signs (City of Albuquerque 2013). The idea of the neon district has also crossed into the virtual world. A Google search for "neon district" leads to multiple results for the neon district in the *inFAMOUS* video game.

NARRATIVE LANDSCAPE

"Remember Eddie's Inferno next to Furr's cafeteria on Central? I wanted to go in there so badly as a kid. I imagined Dean Martin was in there drinking martinis and crooning," wrote Tesuquedog in a comment on the "Born in 'Burque" forum of the *Duke City Fix* website. The collection of signs along a commercial street such as Central Avenue/Route 66 in Albuquerque is more than a set of advertisements. The signs are indicators of social practices and mementos of personal and social events.

The set of signs—the little devil of Eddie's Inferno, the roadrunner of the Chaparral Motel (fig. 2.45), and the jumping frogs of Will's Pool Hall (fig. 2.40)—create a narrative landscape. The landscape of stories is critical to how we understand and value places since "as a species, we are storytellers—we imagine futures, give meaning to our lives by retelling our experiences, and make worlds from words. . . . A city of feeling and meaning inhabits the city of fact . . . this fabric can be a critical part of the sense of home and belonging" (Childs 2012, 50).

This is why, as the authors work on reusing signs, passersby come and tell stories: "My first job was as a busboy in that motel, I was nearly seduced by an older woman

customer"; "My grandparents from Clovis honeymooned there back when it was a swanky place." The concentration of stories within places is why the fictive landscape of signs features in works of other genres, from John D. MacDonald's novel *The Neon Jungle* (1953) to Arcade Fire's album *Neon Bible* (2007). The cultural importance of well-storied places is why in 1999 Congress created the National Park Service's Route 66 Corridor Preservation Program.

Many of the drawings in this collection are of signs that no longer exist. For some signs these drawings are the only remaining documentation we can find. The idea of the great neon way continues, but the stories of many individual signs are fading.

CYCLE OF INSPIRATION

Signs have been inspired by other arts and in turn signs have inspired artists. Moreover, as in any art, the body of previous work serves as fodder for new projects. For example, Zeon artist and designer Keith Kent's charming painting of a fiesta dancer on a Masonite panel was later proposed as a possible design for the Terrace Drive-In sign, resulting in a particularly beautiful neon sign that, although long gone, lingers in the memories of many Albuquerque elders as the epitome of neon sign making (figs. 2.63a, b, c).

The sign designers also borrowed patterns and tropes from the larger cultural context. The Navajo Motors sign (fig. 2.5c), for example, uses patterns from Navajo rugs, and the influence of cartooning is well represented in examples of burger joint signage (figs. 2.31, 2.56, 2.57).

In turn, many artists draw inspiration from the sign designs of the 1950s and '60s, admiring the materials, variety, playfulness, and inventive craftsmanship of the signs from an era that preceded the rise of plastics

Figure 1.9 *El Don* artwork by Noreen Richards based on the El Don sign. Courtesy of Noreen Richards.

and television advertising. Artist Noreen Richards, for example, makes intricate prints that take as a point of departure the doubling and even tripling of line created by hovering neon letters casting shadows upon flat, painted letters on the sign surface (fig. 1.9). Similarly, the famous photograph *Route 66, Albuquerque, New Mexico* (1969) by Ernst Haas gains much of its impact from neon and backlit signs lining both sides of Central Avenue.

Even in their heyday, road signs were commonly reused. This collection of drawings, concentrated in the early 1960s, includes, among many plans for new structures, proposals for adaptations of preexisting signs. Alterations varied in degree as businesses changed hands, from text and name substitutions to complete overhauls of shape.

Zeon and other sign companies currently employ designers and technicians to create new neon signs for businesses in the styles of the historic Route 66 era, and to restore historic signs of landmarks such as Albuquerque's KiMo Theater or the Luna Theater in Clayton, New Mexico. These restoration projects often involve signs that Zeon produced more than fifty years ago and initiate a search for the working drawings of the original signs to guide the restoration process. Lionel Specter, one of the current owners of Zeon, regrets that many decommissioned neon signs ended up back in the Zeon yards, dismantled for scrap and eventually carted off to landfills.

Stand-alone signs require effort to uproot, and grandfathered signs offer a potentially seductive height advantage, so many signs remain steadfast long after their businesses

and even their corresponding buildings vanish. Some orphaned signs along decaying sections of Route 66 are skeletal frames; others are mute, painted-over shapes that have become irregular abstractions. Many are palimpsests, bearing traces of old advertising. Designed to be alluring and magnetic to the eye, associated with simple names or texts, and highly visible to a navigating public, signs remain vivid in memory and serve as shared catalysts of reminiscence. Privately owned commercial advertising becomes a site of collective memory because of the eye-catching imagery, stance of public address, and nearly universal access of road signs.

Artists such as the group Friends of the Orphan Signs (FOS), based in Albuquerque since 2009, look to explore this function of commercial road signs as repositories of memory and as rallying points for community identity. FOS collaborated with a group of students at Highland High School to design new imagery for a skeletal orphan sign at 4119 Central Avenue, installed in 2012 (fig. 4.2). FOS artist Jessamyn Lovell selected a historic photo from the archives of the Albuquerque Museum to reproduce and mount on the nearby Royal Hotel sign, also in 2012, as an ironic tribute to economic cycles of boom and bust to which these signs bear witness (fig. 1.10).

Old, new, and reimagined signs continue to line commercial streets. The individual signs and the "great neon ways" they create are part of the craftwork, urban design, and stories of our cities and towns. The following working drawings add perspective to that heritage and serve as sources for further inspiration.

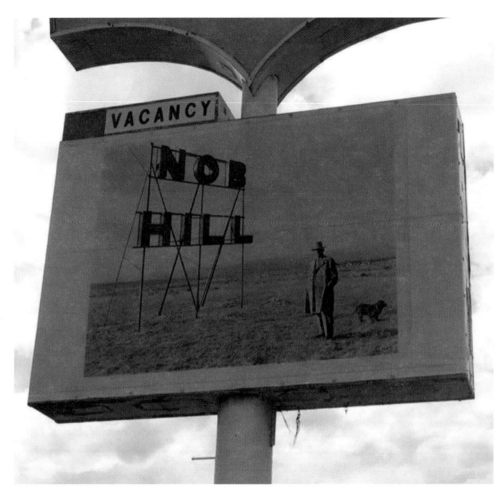

Figure 1.10 Royal Hotel sign with Nob Hill image. Photograph by Ellen D. Babcock. Friends of the Orphan Signs' artist Jessamyn Lovell selected a historic photograph from the Albuquerque Museum archive to place on the Royal Hotel sign. Image courtesy of Friends of the Orphan Signs. Historic image on the sign courtesy of the Albuquerque Museum, #PA1978.141.282.

TWO | *The Working Drawings*

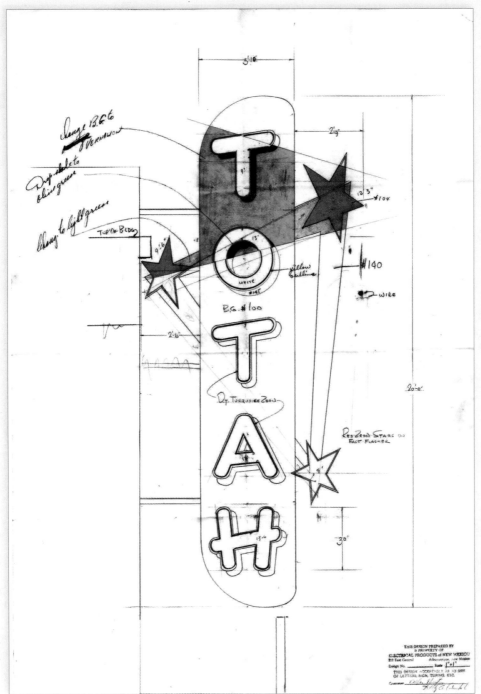

a

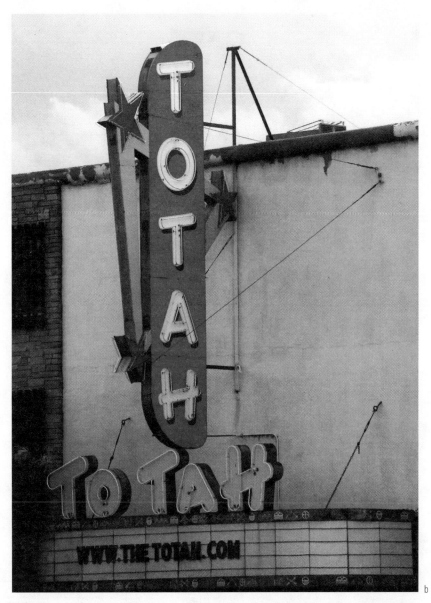

Figures 2.1a and b Totah Theater, Farmington, NM.
(a) Zeon working drawing, 1955. AL1680; (b) Photo-
graph by Mark C. Childs, 2014.

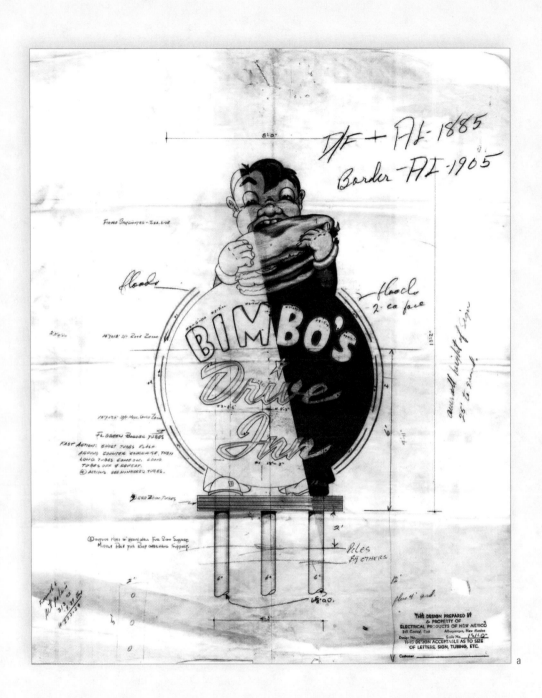

a

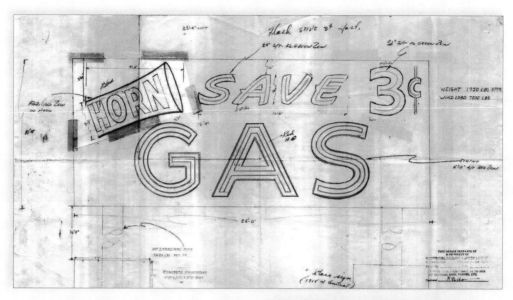

Figure 2.2 Horn Gas, 414 Isleta Boulevard SW, Albuquerque, NM, 1956. AL1762. H. B. Horn established a business in Albuquerque in 1939, starting with a single gas station in the South Valley that grew into the Horn Oil Company, New Mexico's largest independent oil company, before he sold it in 1977. H. B. and Lucille Horn's son Thomas E. Horn, former publisher of the *Bay Area Reporter* and Honorary Consul of Monaco in San Francisco, has supported the renovation/artwork of a former Horn oil sign at 1024 Fourth Street SW in Albuquerque with a grant from the H. B. and Lucille Horn Foundation.

Figures 2.3a, b, and c Bimbo's Inc., 9500 Central Avenue NE, Albuquerque, NM. Albuquerque native Barry Deutch remembers that the Bimbo's burger joint went out of business in the early 1960s and became a bar by the time he was a teenager. He recalls that the former restaurant was altered to include large circular windows facing the street to display go-go dancers. He tells the story of a friend complaining that his parents made him lie down in the backseat whenever they drove by the place so he would be spared the corrupting sight of the dancers (personal communication). (a) Zeon working drawing, 1956. AL1885; (b) Historic photograph of Bimbo's, 5211 East Central Avenue NE, owned by John Machiondo. The restaurant first shows up in the city directory in 1958. Courtesy of the Albuquerque Museum, #1998-030-12; (c) Bimbo's matchbook cover from Mark C. Childs's collection. This is an early example of cross-platform marketing.

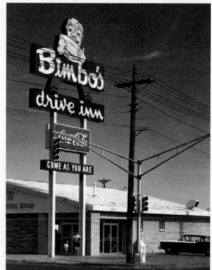

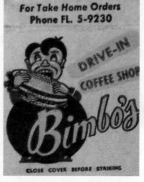

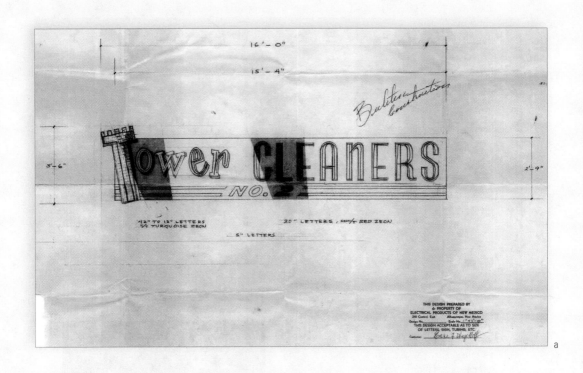

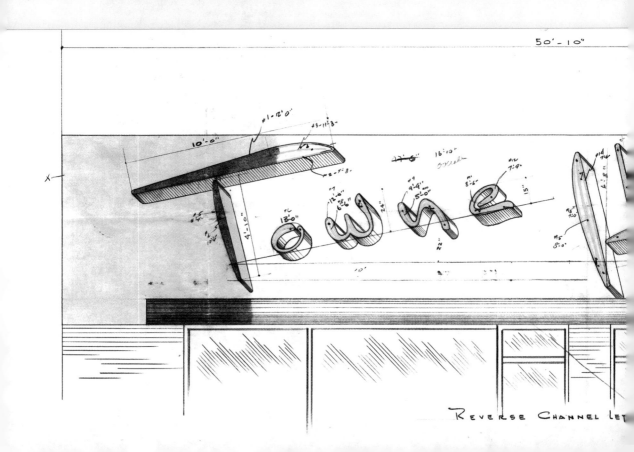

REVERSE CHANNEL LET

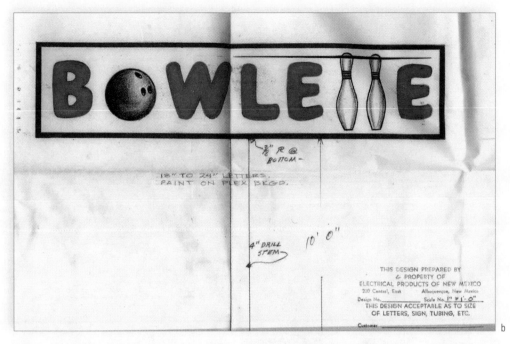

Figures 2.4a, b, and c Graphic use of letters. As seen on these pages, playing with individual letters and fonts was a frequent component of sign design. (a) Tower Cleaners detail, 4506 Fourth Street NW, Albuquerque, NM, 1956. AL1754; (b) Bowlette Corporation, 7800 Lomas NE, Albuquerque, NM, 1960. AL2680; (c) Towne House, 3010 Central Avenue SE, Albuquerque, NM, 1956. AL1831.

c

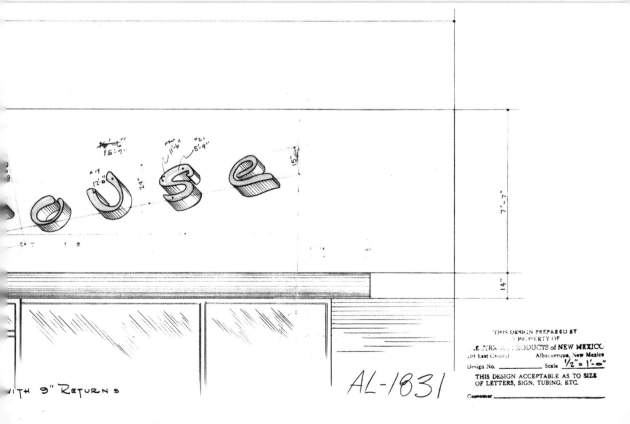

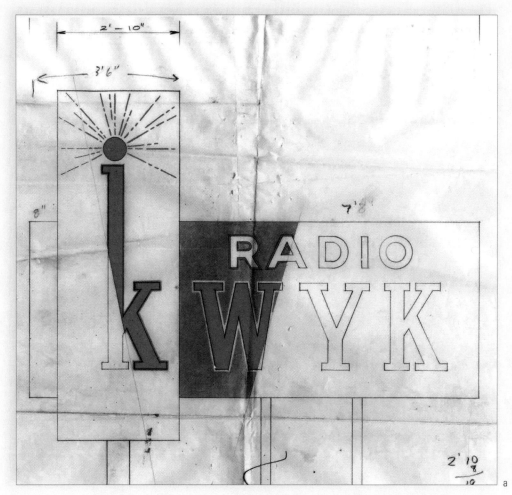

Figures 2.5a, b, and c Graphic use of letters. (a) KWYK
Radio, 203 South Commercial, Farmington, NM, 1969.
AL4897; (b) "W." AL5305; (c) Navajo Motors, 110 East
Sixty-Sixth, Gallup, NM, 1971. AL5580.

ORANGE LIGHTER
BROWN DARKER

USE
PLEX COLOR
2418 BROWN

2'

2'

1"

b

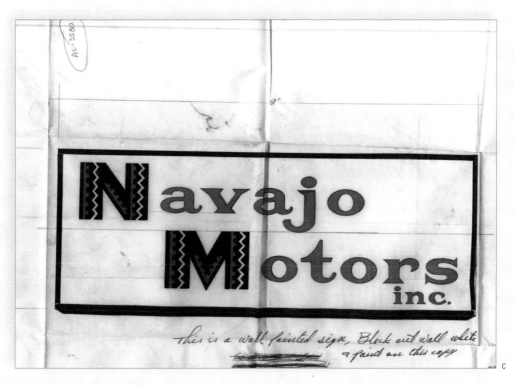

AC-5580

This is a wall painted sign. Block out wall white
& paint on this copy

c

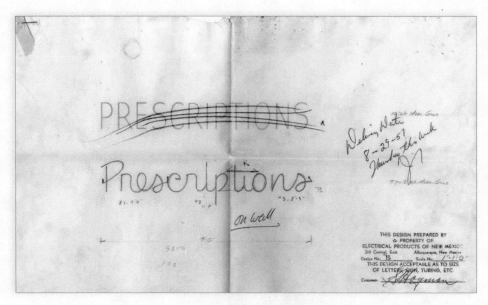

Figure 2.6 Highland Pharmacy, 300 Central Avenue SE, Albuquerque, NM, 1957. AL2024.

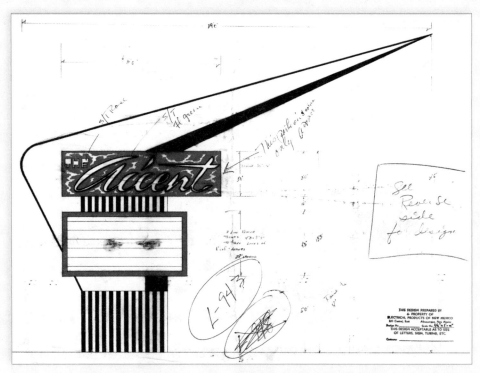

Figure 2.7 The Accent, 2509 San Mateo NE, Albuquerque, NM, 1958. L943.

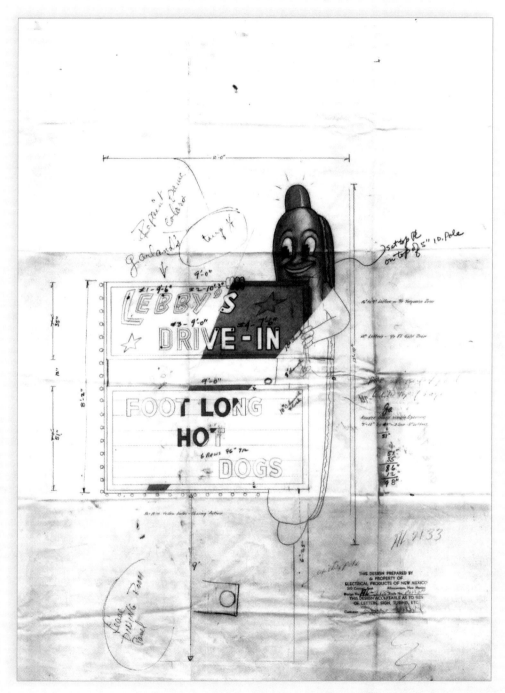

Figure 2.8 Lebby's Drive-In, 2040 Fourth Street NW, Albuquerque, NM, date unknown. AL2133.

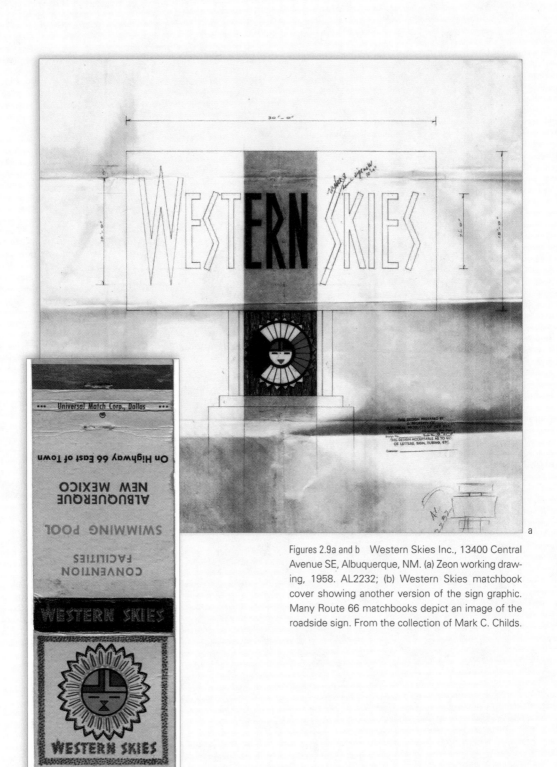

a

b

Figures 2.9a and b Western Skies Inc., 13400 Central Avenue SE, Albuquerque, NM. (a) Zeon working drawing, 1958. AL2232; (b) Western Skies matchbook cover showing another version of the sign graphic. Many Route 66 matchbooks depict an image of the roadside sign. From the collection of Mark C. Childs.

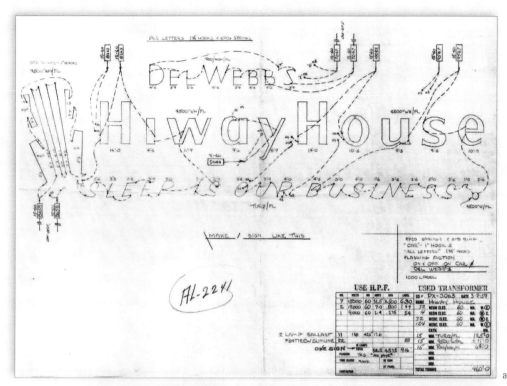

a

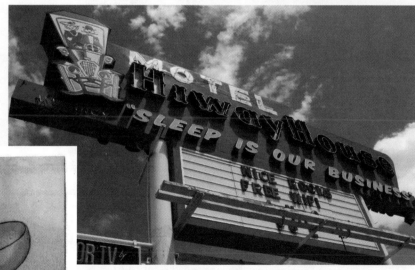

b

Figures 2.10a and b Hiway House, 3200 Central Avenue SE. (a) Zeon working drawing. AL2241; (b) Photograph by Mark C. Childs, 2014.

Figure 2.11 Detail of cocktail from Silver Spur Package Liquors, Jay's Shopping Center, Gallup, 1958. AL2246.

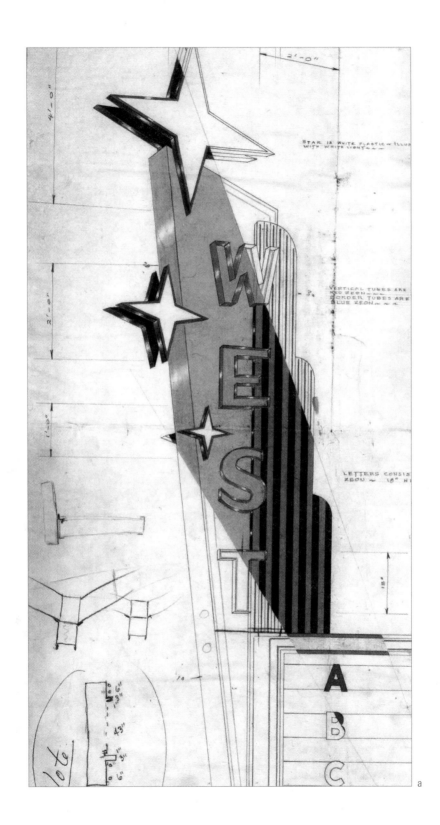

a

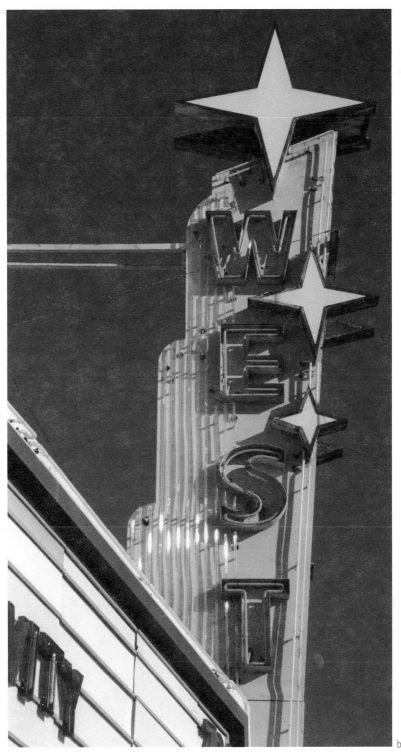

b

Figures 2.12a and b West Theater, 118 West Santa Fe Avenue, Grants, NM. (a) Zeon working drawing, date unknown. AL2291; (b) Photograph by Mark C. Childs, 2013.

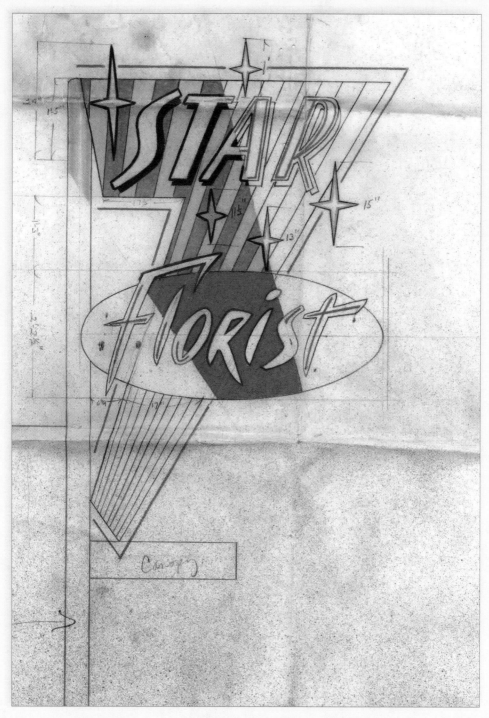

Figure 2.13 Star Florist, 317 Candelaria SW, Albuquer-
que, NM, 1959. AL2336.

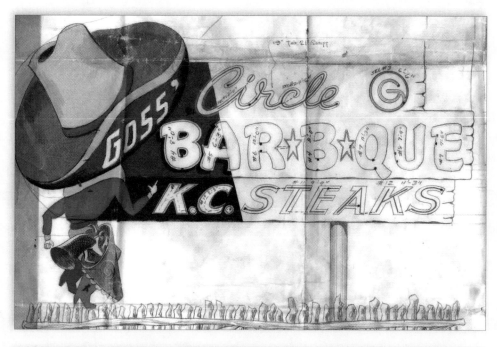

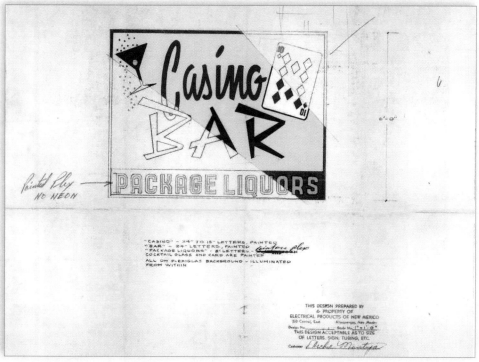

Figure 2.14 Goss Circle G Barbeque, Grants, NM, 1959. AL2340.

Figure 2.15 Casino Bar, 400 Fourth Street NW, Albuquerque, NM, 1960. AL2582.

Figure 2.16 Robin Hood Western Steak House, 2600 Central Avenue SE, Albuquerque, NM, 1960. AL2638.

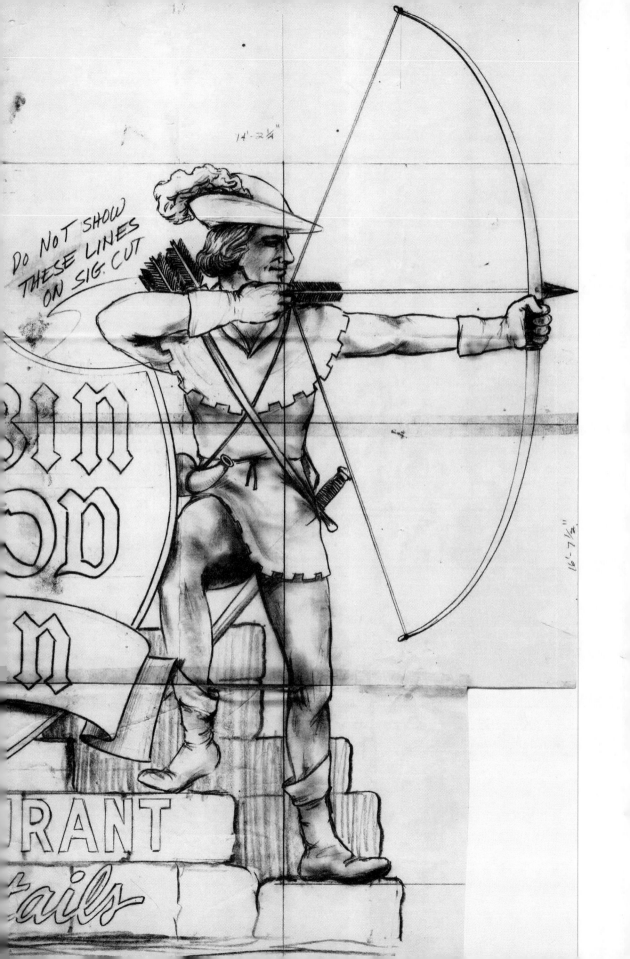

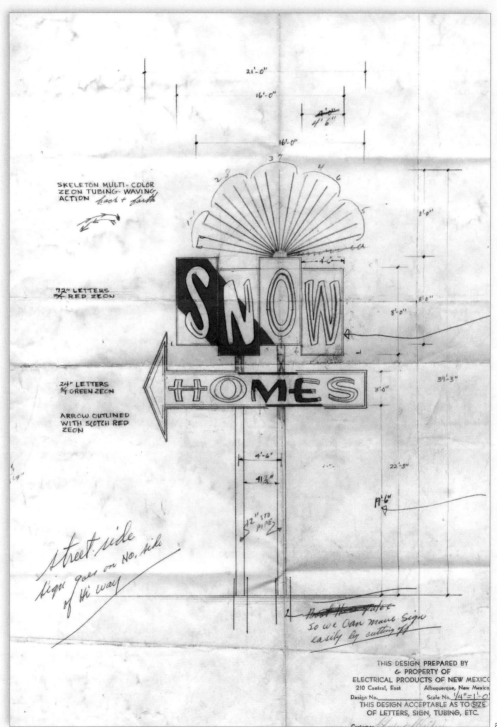

21'-0"

16'-0"

4'-0"
4'-6"

16'-0"

SKELETON MULTI-COLOR
ZEON TUBING- WAVING
ACTION back + forth

72" LETTERS
¾ RED ZEON

24" LETTERS
¾ GREEN ZEON

ARROW OUTLINED
WITH SCOTCH RED
ZEON

3'-0"

8'-0"

8'-0"

39'-3"

4'-6"

4'-6"

4⅓"

12" STD PIPES

22'-3"

A'-6"

street side
sign goes on No. side
of Hi way

so we can move sign
easily by cutting

THIS DESIGN PREPARED BY
& PROPERTY OF
ELECTRICAL PRODUCTS OF NEW MEXICO
210 Central, East Albuquerque, New Mexico
Design No. _____ Scale No. ¼"=1'-0"
THIS DESIGN ACCEPTABLE AS TO SIZE
OF LETTERS, SIGN, TUBING, ETC.

a

Figures 2.17a and b Snow Construction Co. Inc., street address unknown, Albuquerque, NM. Edward H. Snow built the Snow Heights subdivision just east of Hoffmantown starting in 1953. (a) Zeon working drawing, 1959. AL2711; (b) Sheet metal order for Snow Construction Co. Inc. AL2711. In addition to the color drawings of the signs, most files contain sheet metal orders similar to this one.

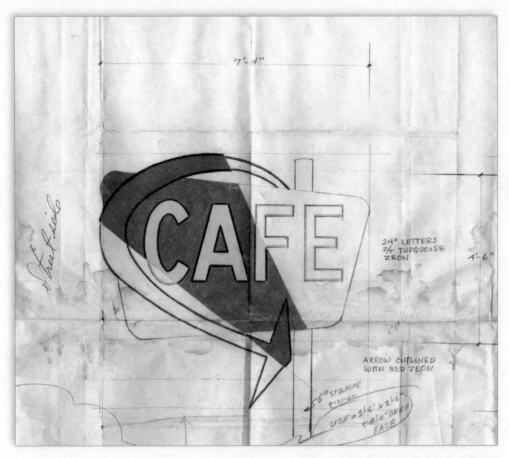

Figure 2.18 Café, Milan, NM, 1960. AL2732.

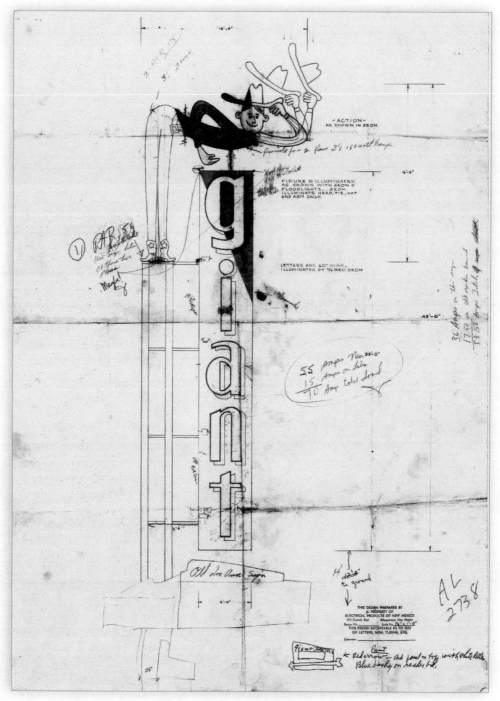

Figure 2.19 Giant Storage Inc., 2914 South Calhoun,
Ft. Wayne, IN, 1960. AL2758.

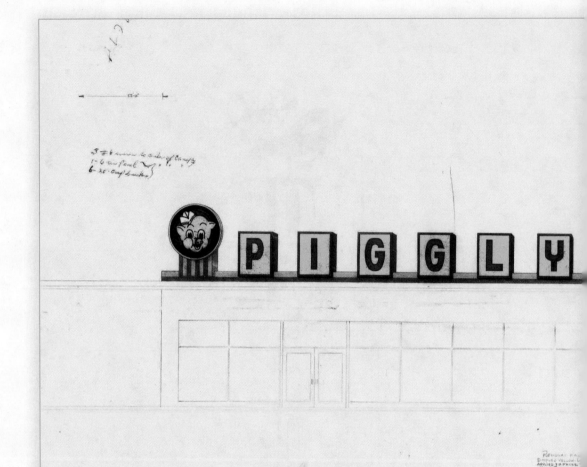

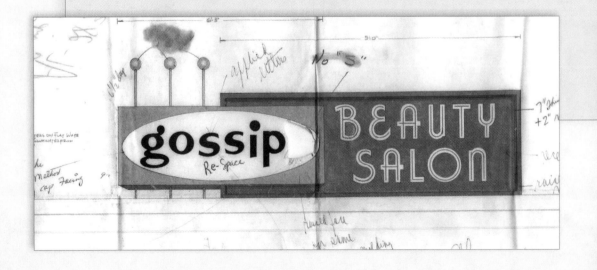

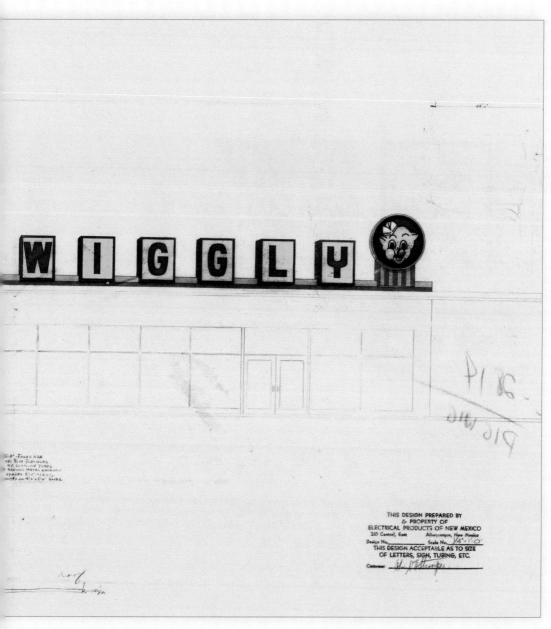

Figure 2.20 Piggly Wiggly, 617 Truman NE, Albuquerque, NM, 1961. AL2814.

Figure 2.21 Gossip Beauty Salon, 932 Eubank NE, Albuquerque, NM, 1960. AL2837.

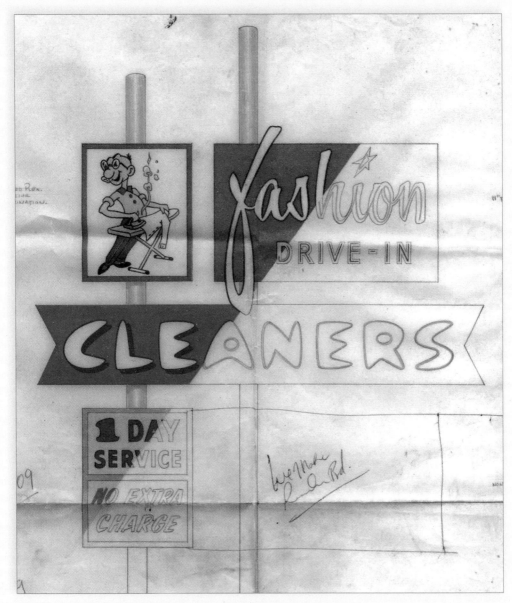

Figure 2.22 Fashion Cleaners and Laundry, 1317 San Mateo SE, Albuquerque, NM, 1960. AL2909.

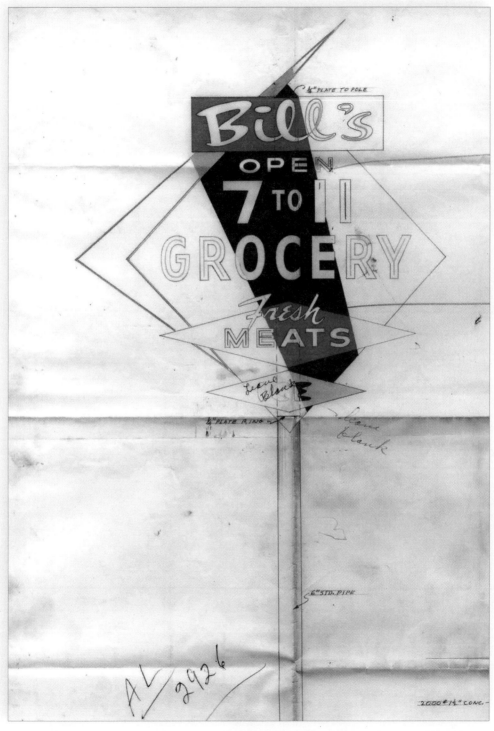

Figure 2.23 Bill's 7 to 11 Grocery, 624 Washington, Grants, NM, 1961. AL2926.

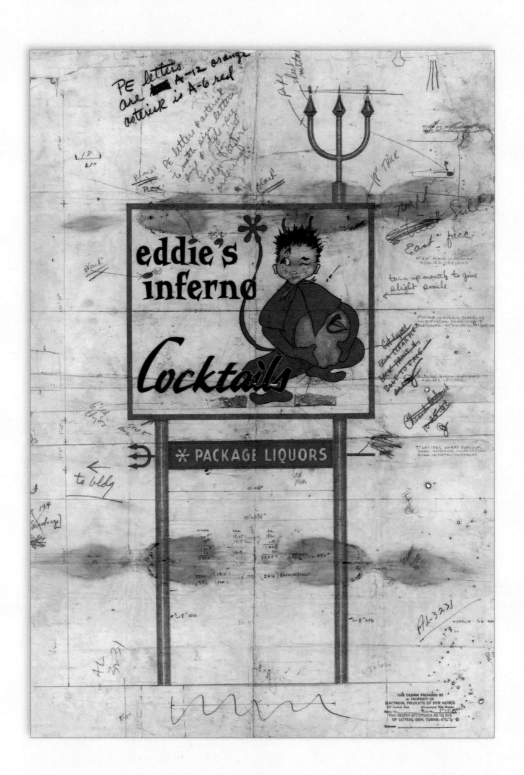

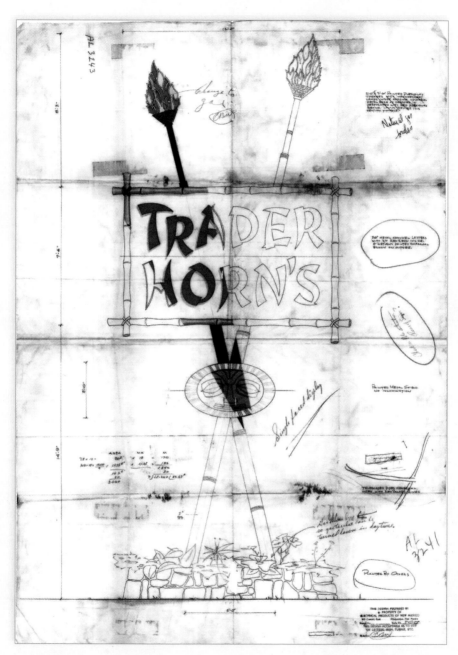

Figure 2.24 Eddie's Inferno, 6016 Central Avenue SE, Albuquerque, NM, 1962. AL3231. Eddie's Inferno remains vivid in many local imaginations as typical of the establishments referred to as either dance halls, nightclubs, or bars that, along with motels, once lined this section of Route 66, each with its alluring neon sign. Albuquerqueans now in their fifties and sixties speak of Saturday nights spent listening and dancing to ranchera music, navigating sawdust-covered floors, and sometimes dodging fistfights and overturned tables at Eddie's (Debbie Hesse, personal communication).

Figure 2.25 Trader Horns, 2420 San Mateo NE, Albuquerque, NM, 1963. AL3241. Trader Horns was ostensibly a Chinese restaurant and bar graced with a giant Tiki at its door.

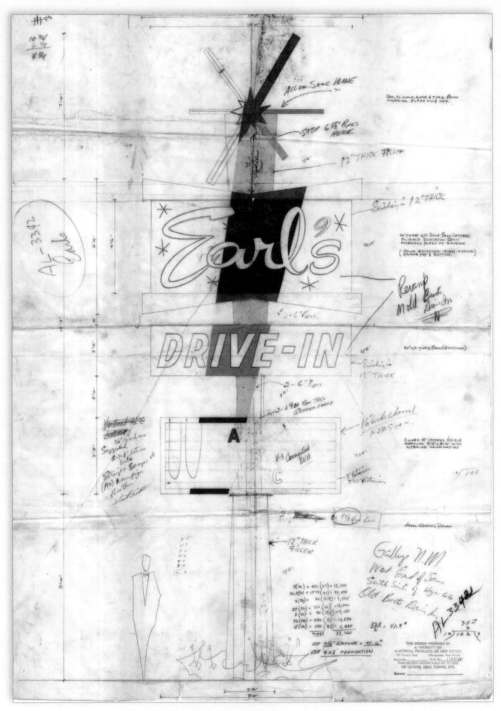

Figure 2.26 Earl's Drive-In, West Sixty-Sixth, Gallup,
NM, 1963. AL3342.

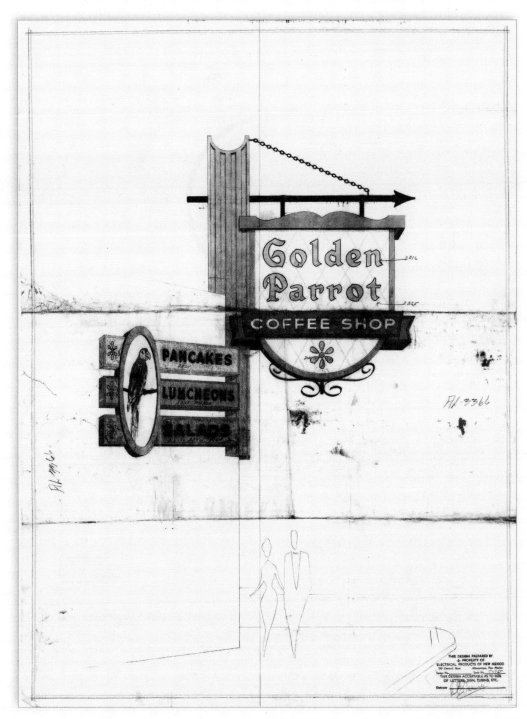

Figure 2.27 Golden Parrot Inc., 125 Second Street NW
(Hilton Hotel), Albuquerque, NM, 1962. AL3366.

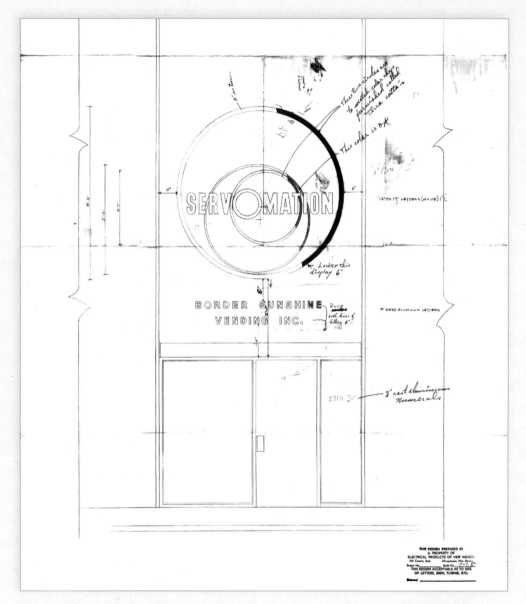

Figure 2.28 Serve O Matic, 2919 Fourth Street NW, Albuquerque, NM, 1963. AL3412. This north Fourth Street building that once housed a vending machine service and repair business is, in 2015, a funeral home. Traces of this sign are still visible on its façade, barely discernible reddish letters that indicate that the business at one point changed its name to Service America. When the funeral home owner bought the building, it contained abandoned pinball machines, jukeboxes, and long metal tables for sorting and counting coins (Ed Hatton, personal communication).

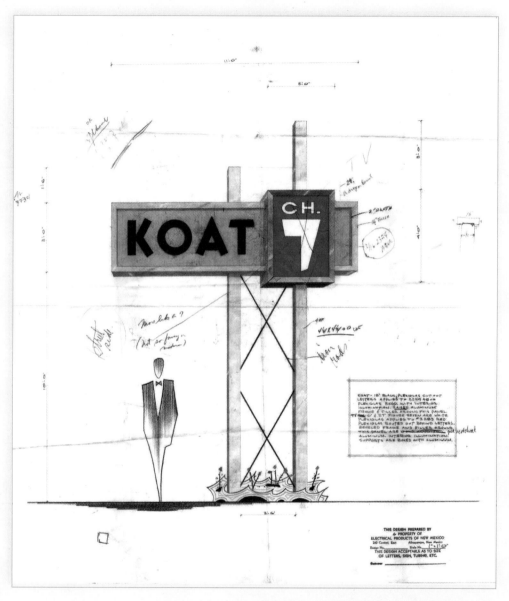

Figure 2.29 KOAT 7, 1377 University Boulevard NE, Albuquerque, NM, 1963. AL3434.

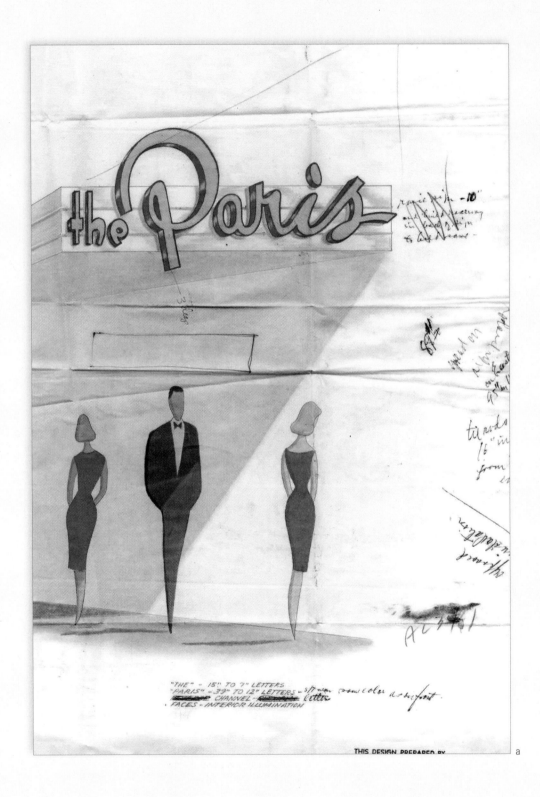

"THE" - 15" TO 7" LETTERS
"PARIS" - 39" TO 12" LETTERS
CHANNEL letter
FACES - INTERIOR ILLUMINATION

THIS DESIGN PREPARED BY

a

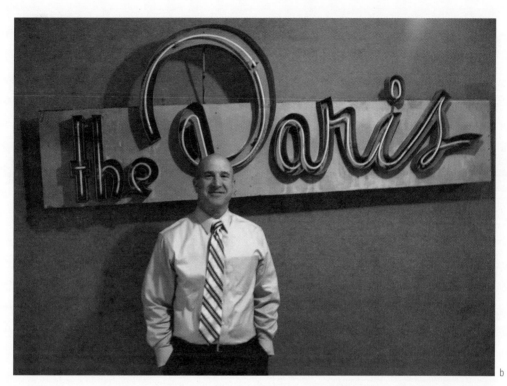

b

Figures 2.30a and b Paris Shoe Shop, 307 Central Avenue NE, Albuquerque, NM. Bob Matteucci Jr. tells the story of his great-grandfather Pompilio Matteucci, an immigrant from Lucca, Italy, who founded this successful business near the turn of the twentieth century. Raised in a farming family, Pompilio learned shoe making while working as a cobbler for the Italian army. With his young wife, he immigrated to New Mexico, passing through Paris on the way. He founded a shoe repair shop, which eventually became one of six retail shops in Albuquerque that sold fashionable, well-made shoes that Pompilio's son Pietro brought from St. Louis.

In the 1930s and '40s most people in Albuquerque bought their shoes at Paris Shoe Shops. In the 1980s business declined and eventually the last remaining shop downtown closed. Not long after, two women, after a night of carousing at a bar downtown, decided to climb onto the roof of the closed business and abscond with the sign. Ten or fifteen years later one of the women ran into Mary Matteucci, and, to clear her conscience, offered to return the sign. It now graces the wall of Bob Matteucci Jr.'s recreation room (personal communication).

(a) Zeon working drawing, 1963. AL3461; (b) Paris Shoe Shop sign in 2014 with Bob Matteucci. Photo by Ellen D. Babcock.

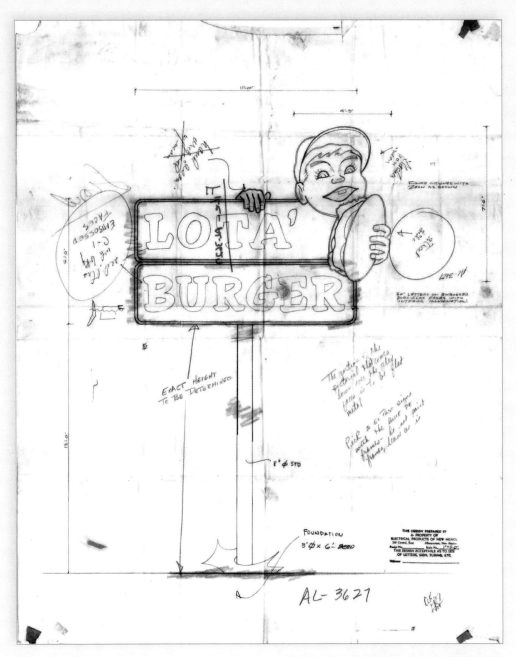

Figure 2.31 Lota Burger, Tucumcari, NM, 1969.
AL3627. "Boy" flashed on and off.

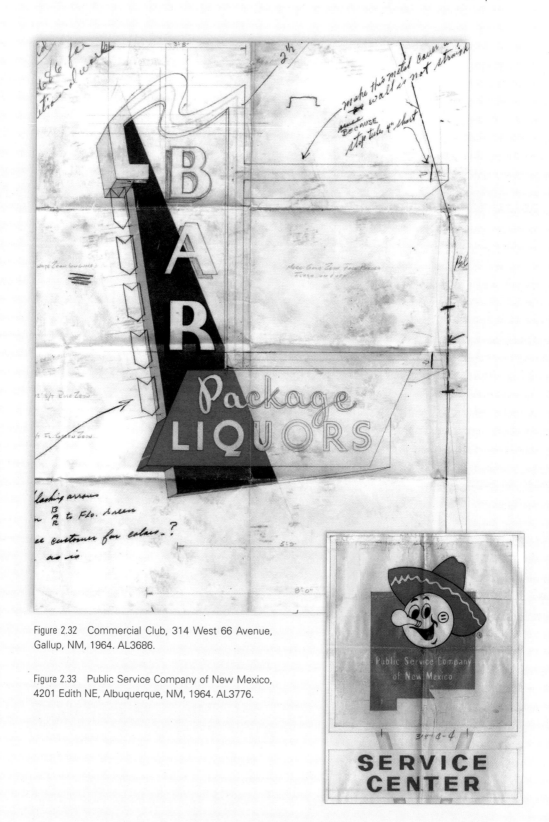

Figure 2.32 Commercial Club, 314 West 66 Avenue,
Gallup, NM, 1964. AL3686.

Figure 2.33 Public Service Company of New Mexico,
4201 Edith NE, Albuquerque, NM, 1964. AL3776.

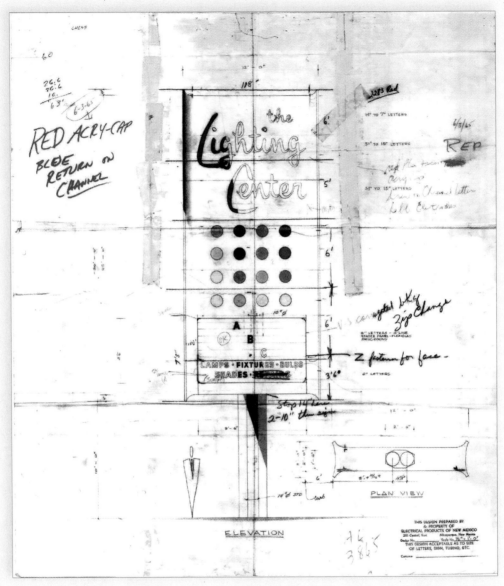

Figure 2.34 Lighting Center, date and address unknown.
AL3865.

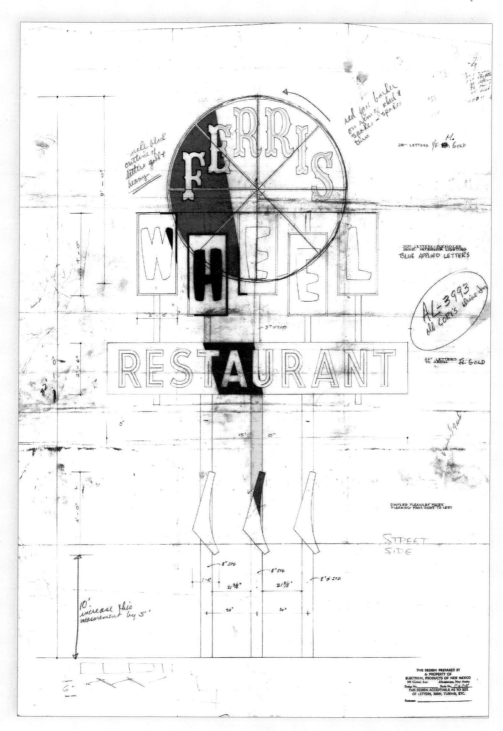

Figure 2.35 Ferris Wheel Restaurant, date and address unknown. AL3993.

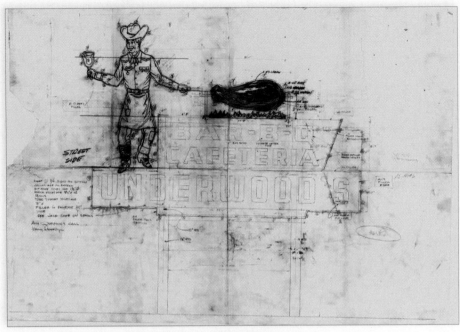

a

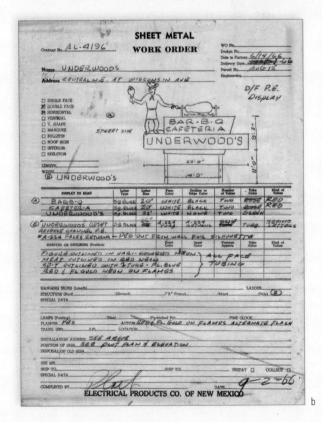

b

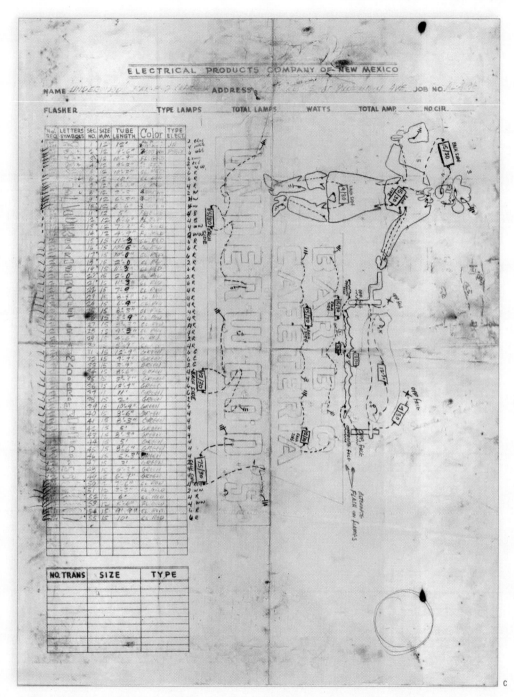

Figures 2.36a, b, and c Underwoods, Central Avenue at Wisconsin Avenue, Albuquerque, NM. More than one Albuquerquean has praised the cherry cobbler served at Underwoods. (a) Zeon working drawing, 1966. AL4196; (b) Wiring diagram of Underwoods. Many files included diagrams of the wiring for the lighting system; (c) sheet metal order for Underwoods.

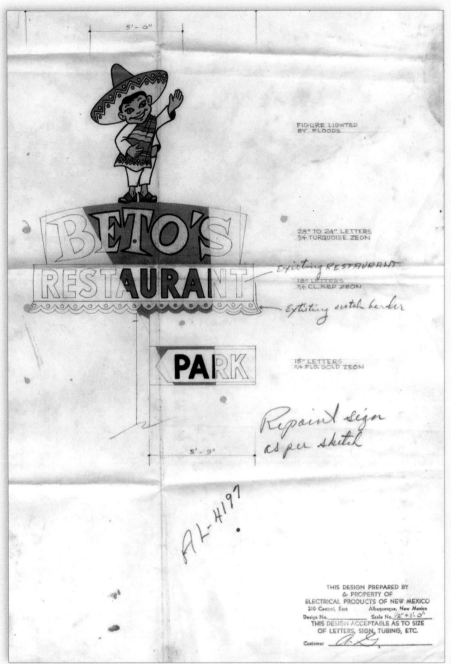

5'- 0"

FIGURE LIGHTED
BY FLOODS

28" TO 24" LETTERS
¾ TURQUOISE ZEON

Existing RESTAURANT

18" LETTERS
¾ CL. RED ZEON

Existing scotch border

15" LETTERS
¾ FLO. GOLD ZEON

Repaint sign
as per sketch

5'- 9"

AL-4197

a

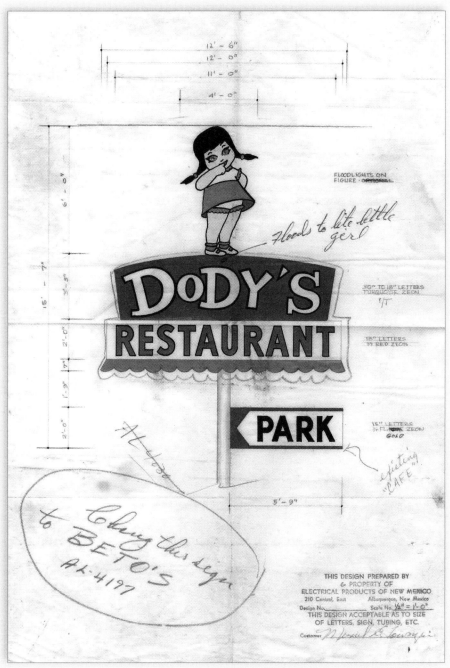

Figures 2.37a and b (a) Beto's Restaurant, 7201 Central Avenue NE, Albuquerque, NM, 1966. AL4197; (b) Dody's Restaurant, "across the street from Beto's," Albuquerque, NM, 1966. AL4197.

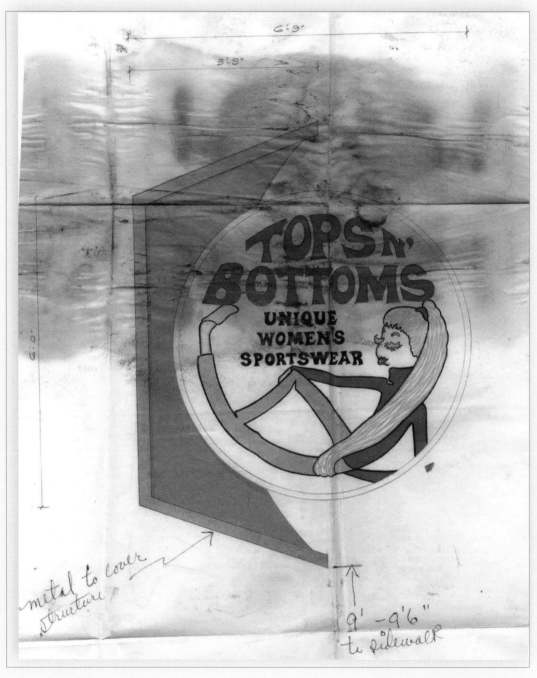

Figure 2.38 Tops and Bottoms, 2222 Central Avenue SE, Albuquerque, NM, 1966. AL4318.

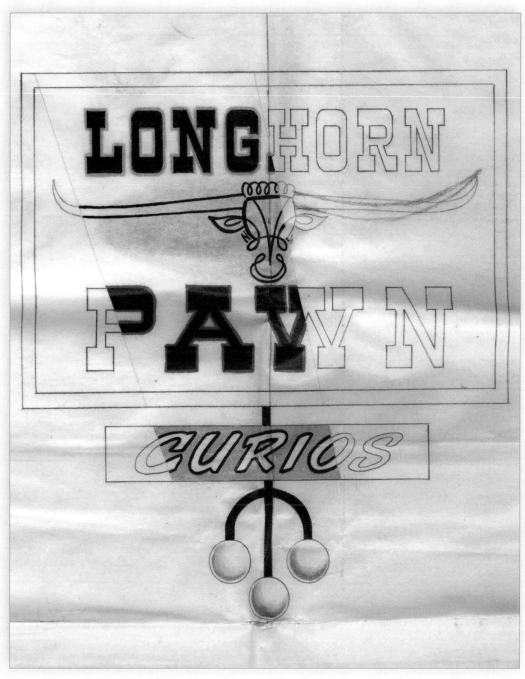

Figure 2.39 Longhorn Pawn, Gallup, NM, 1967.
AL4536.

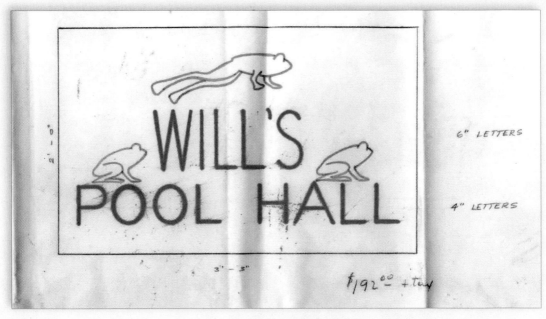

Figure 2.40 Will's Pool Hall, Taro Road, Santa Fe, NM, 1968. AL4655.

Figure 2.41 Ballut Abyad Shrine Temple, 809 Copper NW, Albuquerque, NM, 1968. AL4668. The façade of this striking building at 809 Copper NW serves in 2015 as offices for the Mid-Region Council of Governments. It was built in 1906 and was at one point an opera house before the Shriners acquired it in 1950. Informally known as the Fez Club house, members of the Albuquerque chapter of the Ancient Arabic Order of the Nobles of the Mystic Shrine (now Shriners International) assembled there. This fraternal organization founded hospitals that continue to provide care for children.

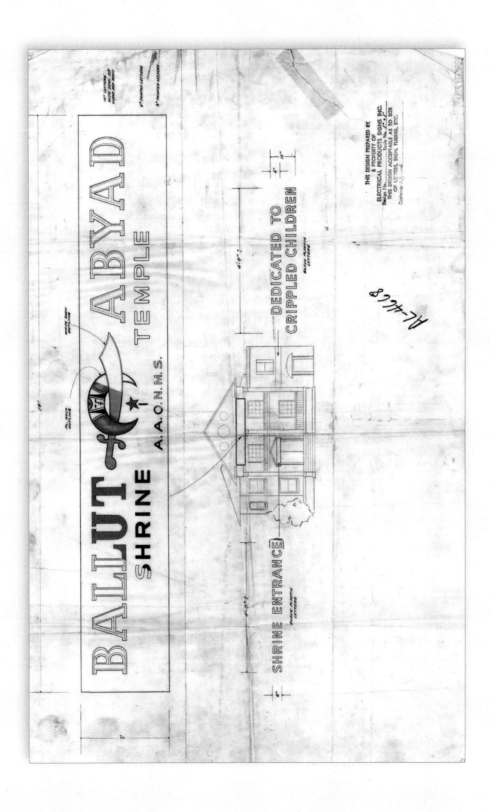

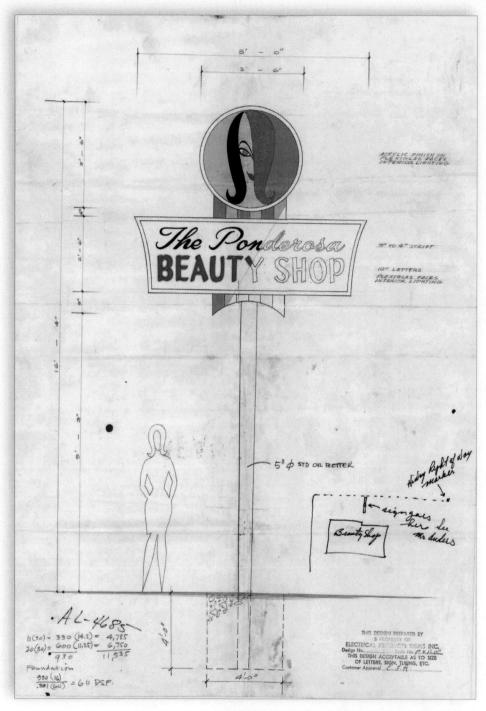

Figure 2.42 The Ponderosa Beauty Shop, 10610 Central Avenue SE, Albuquerque, NM, 1968. AL4685.

Figure 2.43 Little Bear Enterprises Inc., Gallup, NM, 1968.
AL4760.

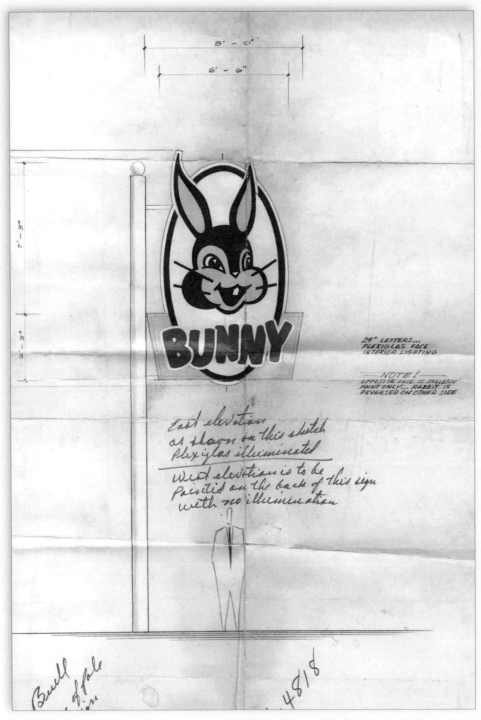

Figure 2.44 Meads Food Inc., 717 Coal Avenue, Albuquerque, NM, 1968. AL4818.

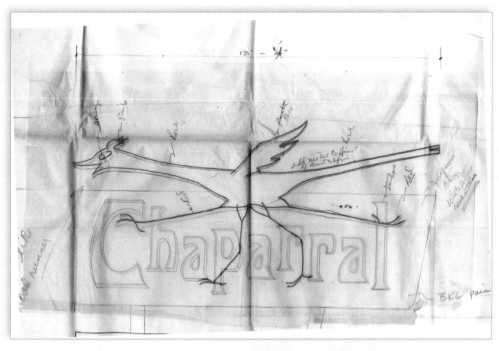

Figure 2.45 Chaparral Motel, 5937 Fourth Street NW, Albuquerque, NM, 1969. AL4832.

Figure 2.46 Detail of scale figure from a Casa de Belleza drawing, 9220 Menaul NE, Albuquerque, NM, 1969. AL4854.

TUBING LAYOUT

Figure 2.47 Detail of tubing layout for J. J. Newberry Co.,
New York, NY, 1969. AL4866.

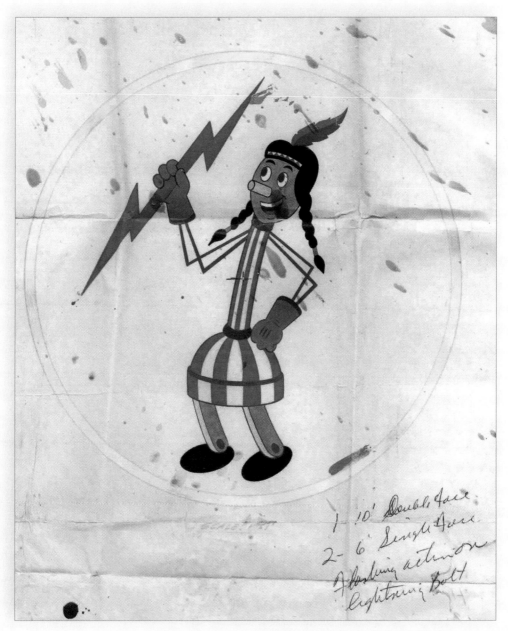

Figure 2.48 Jemez Mountain Electric Coop Inc.,
Española, NM, 1969. AL4922.

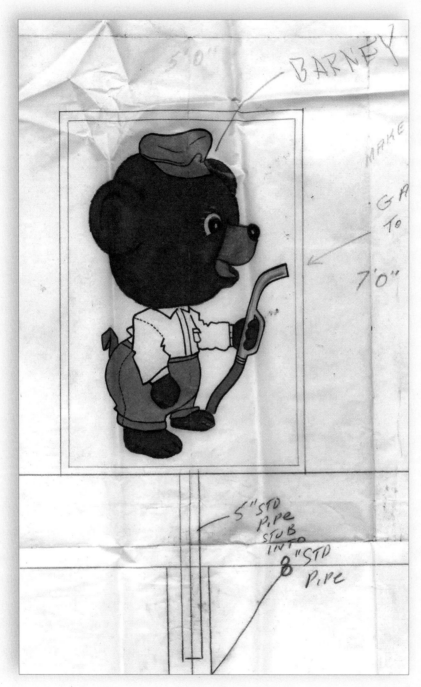

Figure 2.49 Little Bear, Gallup, NM, 1969. AL5089.

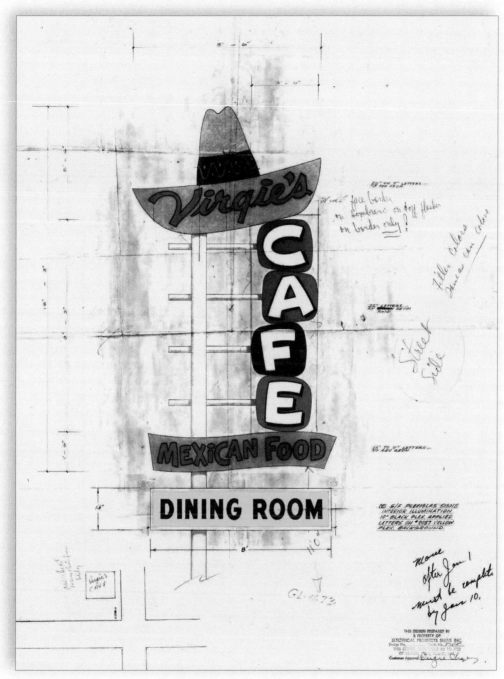

Figure 2.50 Virgie's Café, 1507 Kit Carson, Gallup, NM, 1969. AL5098.

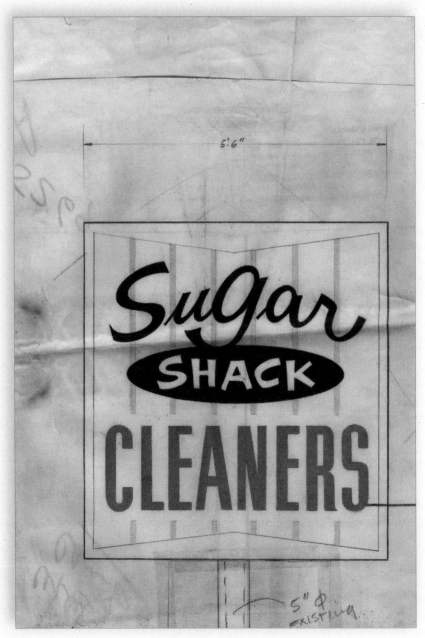

Figure 2.51 Sugar Shack Cleaners, 109 Yale SE, Albuquerque, NM, 1970. AL5269.

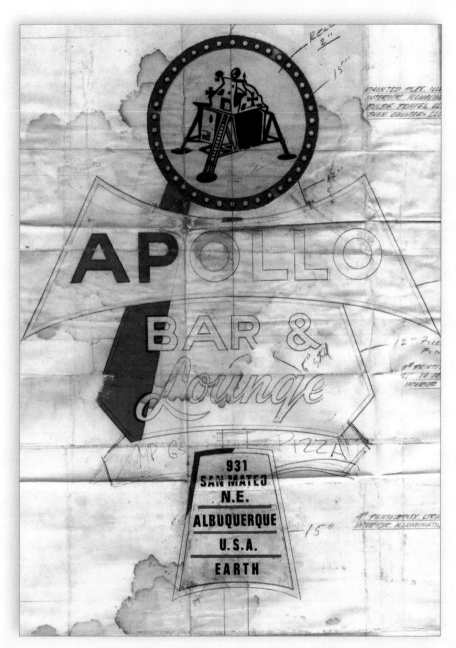

Figure 2.52 Apollo Bar and Lounge, 931 San Mateo NE, Albuquerque, NM, 1970. AL5277. The Apollo, in a bowling alley at San Mateo and Lomas, has been described as a dive bar with a tiny stage and dance floor. It was "affectionately known as the Appalling Lounge by some of those who played music there" (La Fanciulla del West, August 11, 2008 [6:49 p.m.], comment on Ramblings2, *Duke City Fix* [website], www.dukecityfix.com). Alternately, its name was pronounced in Spanish—A Pollo (Glen Effertz, August 12, 2008 [7:06 p.m.], comment on Ramblings2, *Duke City Fix* [website], www.dukecityfix.com).

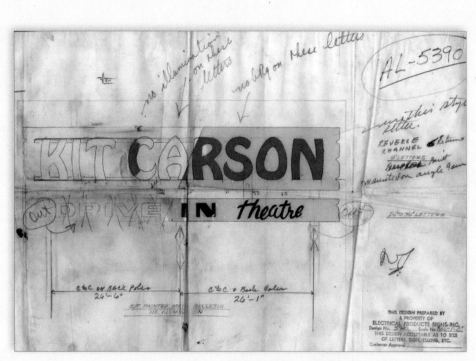

Figure 2.53 Kit Carson Drive-In, Taos, NM, 1970.
AL5390.

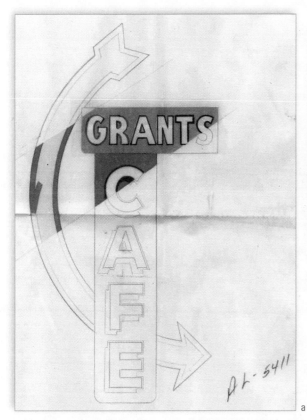

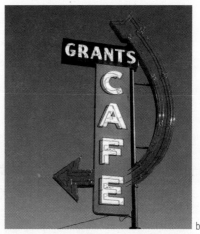

Figure 2.54a and b Grants Café, 809 Huston, Grants, NM. (a) Zeon working drawing, 1971. AL5411; (b) Photograph of refurbished Grants Café sign by Mark C. Childs, 2013.

Figure 2.55 Stella's Beauty Salon, 208 Wyoming SE, Albuquerque, NM, 1971. AL5434.

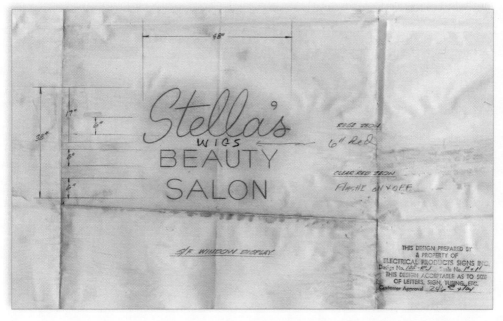

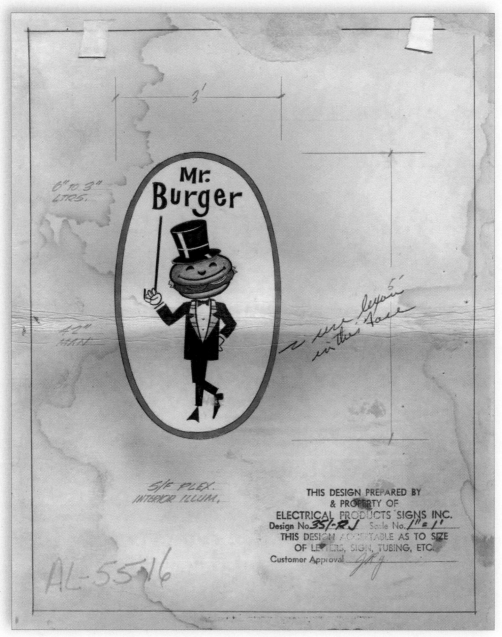

Figure 2.56 Mr. Burger Drive-In, Española, NM, 1971. AL5516.

Figure 2.57 Stufy, Mexican Made Foods, 922 Coal Avenue, Albuquerque, NM, 1971. AL5535.

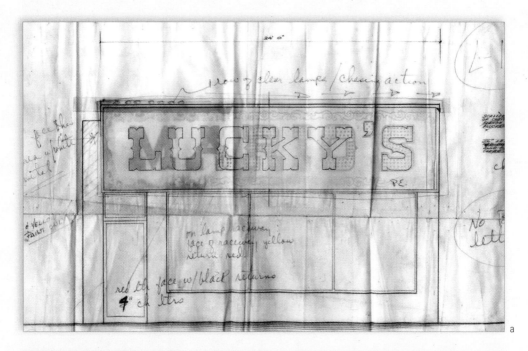

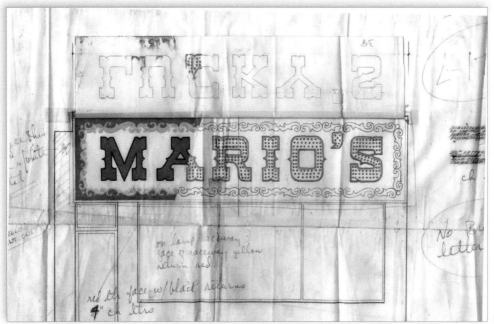

Figures 2.58a and b (a) Lucky's Incorporated, 4513 Central Avenue NE, Albuquerque, NM, 1971. AL5657. This drawing illustrates adaptive reuse of existing signs as businesses changed; (b) Mario's sign prior to the conversion to the Lucky's sign in figure 2.58a.

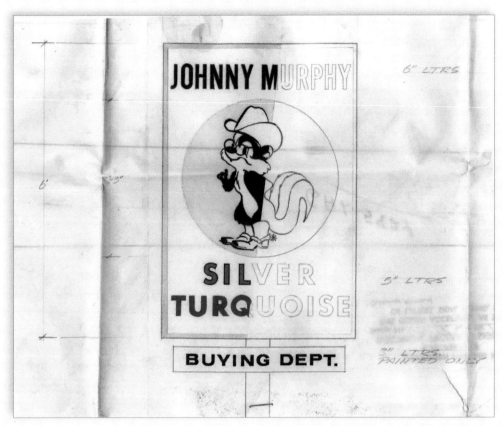

Figure 2.59 Johnny Murphy, Vanderwagen, NM, 1972.
AL5824.

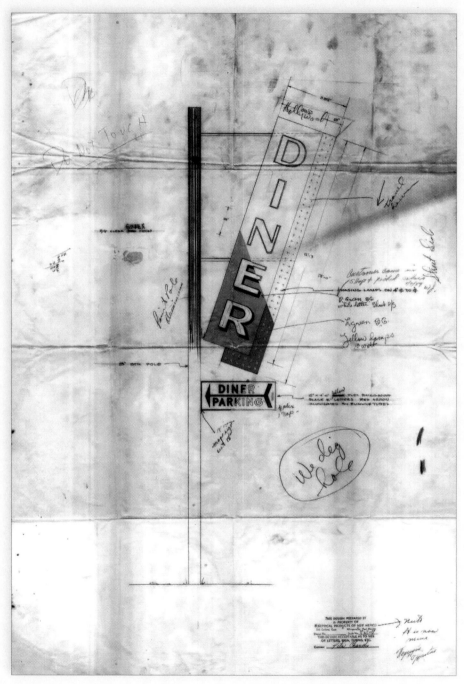

Figure 2.60 Diner, loose in files.

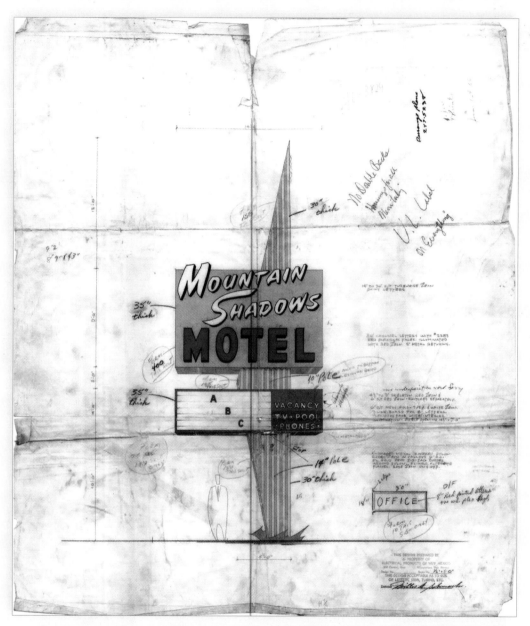

Figure 2.61 Mountain Shadows Motel, 3255 Main, Durango, CO, 1965. AL4829.

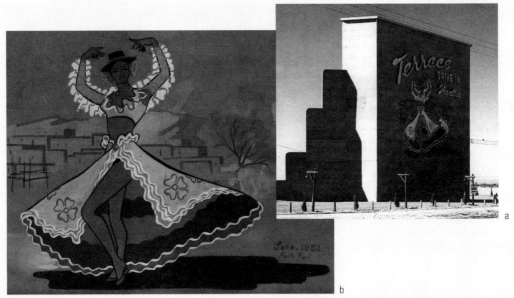

a

b

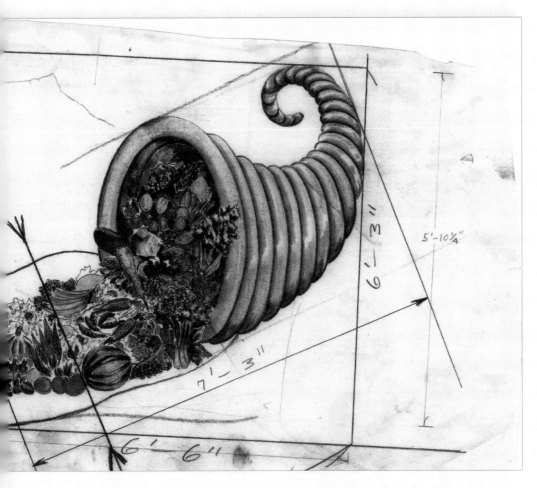

Figure 2.62 Cornucopia, loose in files.

Figures 2.63a, b, and c (a) Photograph of the Terrace Drive-In. Courtesy of the Albuquerque Museum, #1980-186-796; (b) Original artwork for the Terrace Drive-In sign by Keith Kent. Photograph by Ellen D. Babcock; (c) Advertisement for the Terrace Drive-In including a drawing of the flamenco dancer neon sign, © the *Albuquerque Journal*. Reprinted with permission. Permission does not imply endorsement.

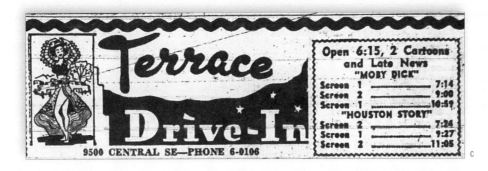

16'-0"

3'

2'8"

1'

THREE. | *The People of Zeon*

4' 0"
4' 6"

2

6

5

8'-0'

In the early 1920s a young roofer in Denver named Wilbur Jones was straddling a building and happened to glance over into the backyard of the sign company next door where workers were testing neon. Declaring it the most amazing thing he had ever seen, he showed up the next day and offered to work for the company called Quality, Reliability and Service (QRS), which eventually gave rise to Zeon Signs.

In 1938 Jones was sent from Denver to open a branch in Albuquerque with Dave Specter and Al Smith. In 1941, barely established, this fledgling branch had to close because of the massive reallocation to the war effort of materials essential to sign production such as sheet metal. Wilbur Jones went to work for the state of New Mexico as an electrical inspector; Dave Specter joined the Air Corps. When the war ended, the men picked up where they left off, and in 1945 Wilbur, Dave, and Al established their own Electrical Products Co., a.k.a. Zeon, with a main shop at 210 Central Avenue, a sales office east of Nob Hill, and eventually a larger compound on Fifth Street.

Here we outline the history of Zeon and describe the division of labor and tasks of sign making. We introduce workers and craftspeople that have been key to the success and distinct character of the company

and describe production details of some of the remarkable midcentury signs Zeon created. Finally, we discuss current restoration and art projects that continue to employ the talents and skills of sign makers.

During the early years of Zeon, Dave Specter worked the front end, managing finances and customer relations, Wilbur Jones headed production and installation, and the two eventually bought out their third partner, Al Smith. Lionel Specter, Dave's son, recalls that Wilbur was respected as a highly skilled craftsman, and that his father was fond of declaring that Wilbur "could make a Swiss watch with a ball peen hammer" (personal communication). As business flourished in the 1950s, the company expanded to include branches in Farmington, Gallup, and Las Cruces. In the *Albuquerque Journal*'s "Industry of the Week" article of March 30, 1958, Dick Skrondahl features Zeon and describes the sign-making process:

> All of the designing, painting and manufacturing of the signs is done by separate departments at the Fifth Street plant. When a sign is to be made, the art and design department work out an eye-appealing layout that will serve the needs of the customer and will fit his particular area. After the sign is approved, the engineering department outlines the specifications and produces a drawing of the sign in the exact size it will be. A carbon of the drawing is made on asbestos and the glass workers begin their phase of the operation. Four-foot tubes of special glass are heated and bent to conform to the drawings.
> Electrodes are welded to the tubes and they are ready for the coloring department. Here the tubes are filled with gas that reacts in a certain color to an electrical current. Neon, for example, will produce a reddish-orange glow in a clear glass tube. After each section of the tube part of the sign has been filled and checked, it is burned for 48 hours in the plant to insure constant color with no impurities. Meanwhile, sheet metal men are constructing the sign background and supports, which on completion are sent to the paint shop for two coats of weather resistant automotive enamel. When the sign is dry and the tubing has been "pre-burned" they are ready for delivery and installation. Sign electricians and installation men, working with trucks and cranes, finish the job.

ARTISTS

The designers who created the drawings in this collection were referred to as artists, and some, but not all, had formal art training.* Usually they did not sign their work. Brothers Larry and Johnnie Plath, grandsons of Wilbur Jones and owners of their own sign company called Southwest Outdoor Electric, debate one aspect of Skrondahl's description of the process, recalling from their childhoods in the 1960s that the artists were not housed at the Fifth Street plant but at the sales office miles away. This would help to account for the extensive handwritten notations on the drawings

* For example, Thomas Pillsbury described his first job as a young teen painting signs followed by fine-art training at the Chicago Academy of Fine Arts. Pillsbury was an exhibiting artist who supplemented his income by set painting for theater and film productions as well as sign design and painting. "In 1953 I moved to Albuquerque, basically to work for another sign shop as a designer of neon signs. It was my duty to make the patterns and original sketches that the salesmen needed" (Thomas G. Pillsbury, interview by John H. McNeely, May 21, 1974, "Interview no. 131," Institute of Oral History, University of Texas at El Paso).

Figure 3.1 Wilbur Jones in 1929. Courtesy of John and Larry Plath.

Figure 3.2 Zeon workers circa 1961 in front of a gas station sign. Production jobs were divided into artists (designers), painters, engineers, installers, glassworkers, sheet metal workers (tinners), and electricians. Photograph courtesy of Kevin Kent.

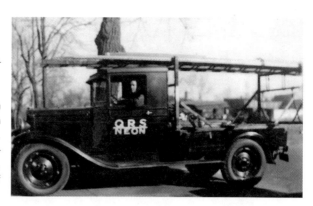

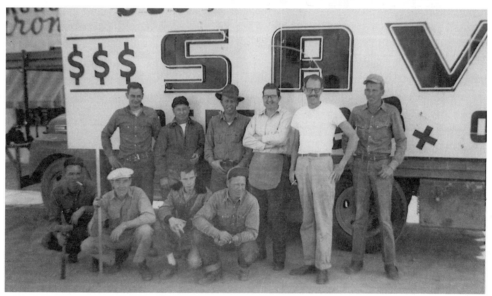

Figure 3.3 Names written on the back of the photograph. Kevin Kent keeps this framed photo on his desk at Zeon. Linda Wood, in an email to the authors in 2014, writes,

> My father, Louis C. Neely, a former electrician, built and hung neon signs back in the '50s–'60s for Electrical Products/Zeon Signs in Albuquerque and throughout the State of New Mexico.

He was a good friend of one of two artists, Keith Kent, and Carl Stehwein. As I recall, my dad worked there about 15–16 years, under Willie and George Jones. I believe Willie was the owner. I was just a kid back then. Some of the men he worked with at Electrical Products/Zeon, David Keith, Homer Bostic, Chester Crow, Leonard Gibbs, Johnny Carlton, Charley Coons, Ron Poteet, Keith Kent, Jerry Keith, and Carl Stehwein, and others I cannot recall, remained friends for many years. Most of them passed on before my father did. I remember going to the sign shop as a child and watching them do glassblowing, creating intricate designs and lettering for the signs. It was a magical place.

facilitating communication between geographically separated departments.

Ralph Johnson, an artist recruited by Zeon at a sign convention in Chicago in 1959, worked with the company until his death a few years ago, presumably creating a large share of these drawings. He worked by hand until a shift to digital methods in the 1990s led to his move to the engineering department.

Artist Keith Kent's son Kevin currently operates the computers, digital printers, and vinyl cutters installed in one of the older buildings at the company compound, right in front of the obsolete scaling-up grid. The fading lines marked on the wall are still framed by heavy black curtains that once helped to focus and brighten the light of opaque projectors. Craftspeople used the projectors to scale the original drawings to the size of the enormous signs. The curtains now function as space dividers and protect delicately clicking digital printers from dust.

PAINTERS

The Plath brothers like to talk about the skill of the sign makers they remember. They recall the assuredness of the painters as they connected in swift strokes the dots left on the sign surfaces by template paper, perforated along the lines and "pounced" by mesh bags filled with colored chalk. This process would leave fine powder markings on the substrate, usually steel sheet metal, that served as guidelines for the painters. Painters were often challenged to create clean lines while on scaffolding or ladders. The Plaths mention Walt Prythero, who sang opera while he painted signs in public, drawing an audience at the bottom of his ladder. Larry and Johnnie Plath also admire the innovation of the glassblowers and engineers and the fearlessness of the installers.

GLASSBLOWERS

Jere Pelletier, one of the current owners of Zeon, entered the sign business as an apprentice in 1941, then moved to Farmington in 1958 to work for Zeon there until his move in 1970 to the main Albuquerque headquarters. Amiable and talkative, Jere is a consummately skilled glassblower. He is a craftsman at heating, bending, and shaping the delicate glass tubing and filling it with electrically charged gases. Jere can trace the changes in sign-production materials and processes he has witnessed over sixty years, from porcelain enamel on the steel signs of the auto and tire companies Ford, General Motors, Goodyear, and Firestone, already going out of fashion when he started making signs in the late 1940s, to the midcentury heyday of neon, which he evokes wistfully.

Jere believes the most remarkable Albuquerque signs Zeon made in this era are the elegant Fiesta Lanes bowling pin (fig. 1.1); the Public Service Company of New Mexico's Reddy Kilowatt sign downtown with its neon lightning bolt; the giant rotating letters above the roof of the First National Bank; the soaring, sail-shaped Trade Winds Motel sign (fig. 3.4); and the nearly mythical Terrace Drive-In flamenco dancer sign (figs. 2.63a, b, c). Only two small, disappointing photographs have been found of the late 1950s or early '60s Terrace sign, but it remains vivid and impressive in the memories of many longtime Albuquerque residents and sign makers.[*]

[*] For example, Anna Manana writes, "I'm trying very hard to track down a color photograph of the gorgeous neon flamenco dancer on the Terrace Drive-In . . . its street sidewall. The Albuquerque Museum and other sources all have black-and-white ones taken in the daytime but so far no luck on the lady in her full nighttime glory" (August 10, 2012 [7:54 pm], comment on *Duke City Fix* [website], www.dukecityfix.com).

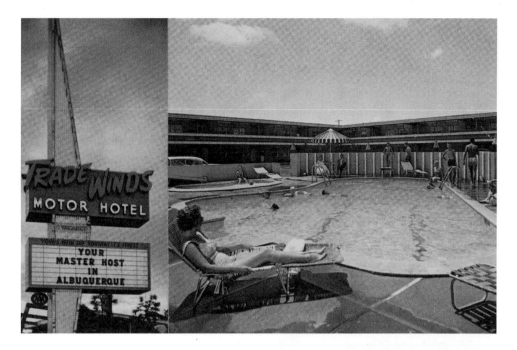

Figure 3.4 Postcard featuring the Trade Winds from Ellen D. Babcock's collection. In the 1950s and '60s, the Trade Winds Motel was a relatively luxurious destination for travelers. An Albuquerque native recounted to the authors memories of her parents from Clovis, New Mexico, telling stories of their glamorous honeymoon there in the 1960s.

Figure 3.5 Zeon glassblower Corey Clark bending glass tubes, January 2015. Photograph by Ellen D. Babcock.

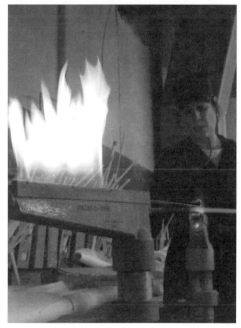

Figure 3.6 Photograph of Zeon trucks parked in front of the El Rey Theater. Courtesy of the Albuquerque Museum, file number unknown.

Corey Clark has been Zeon's sole glass-blower for nearly fifteen years. She works in one of the older buildings of the Zeon compound, a cavernous warehouse that also houses dusty bins of vintage letters arranged by alphabet and an enormous, obsolete scaling-up grid painted on one wall. Rolled-up paper patterns and tubes of glass are lit by the perpetual flames of several gas burners that line her working table. She blows air from her mouth through a thin rubber tube into the glass tube she heats and shapes, keeping it from collapsing. She stops periodically to test the glass line she creates against the penciled traces on a singed paper pattern covered by a metal screen, forming the loops and curves of neon letters. Paper and screen have replaced asbestos pattern surfaces, and the glass tubes no longer contain lead, but the process remains much the same as it was over fifty years ago (fig. 3.5).

INSTALLERS

Sign production and installation was, and still can be, dangerous labor. Glassblowers encountered asbestos and lead, frequent burns, and cuts, while installers faced wind and exposure, dizzying heights, and nearby power lines. Installers on service calls often climbed though hatches inside large sign letters to replace bulbs. Larry Plath, himself a survivor of a thirty-foot fall from a ladder blown askew by a sudden gust, tells a story of a worker trapped inside a letter of the giant First National Bank sign supposedly stabilized for service and finding himself rotated off the ladder and roof. Staring through the bottom hatch at the ground hundreds of feet below, he yelled at the top of his lungs until he finally got help to bring the letter back around. The Plaths remember tagging along as boys to installations of large signs and recount their father's and grandfather's tales of the challenges of setting them in place before the advent of

welding, bucket lifts, and percussive drills. Installing theater marquees and motel signs required the construction of an A-frame structure on the roof (or for smaller signs, a long steel horizontal pipe with the boys sitting on one end as counterweights). A rope was run from a block and tackle on the A-frame and tied to a Zeon truck. The truck slowly and carefully backed down the street to hoist the sign. Safely securing the signs was laborious and slow. The installers had to hand-hammer bolt holes in masonry with a star drill bit (fig. 3.6).

TRANSITION TO PLASTIC

According to Jere Pelletier, lightweight, sturdy, and cheaper plastic sign faces lit from the interior by fluorescent tubes began appearing in the southwest in the late 1940s and early '50s. Signs that advertised beer—Hamm's, Schlitz, and Miller Lite—led the way. Most companies abandoned exposed neon for less expensive and easily maintained backlit plastic signs by the 1970s, and with waning demand, the number of Zeon's glassblowers dwindled from six at peak demand to one today.

CURRENT BUSINESS

Wilbur Jones and Dave Specter sold Zeon in 1969 to Mullins Broadcasting, a company subsequently bought by Combined Communications. In the early 1980s Thomas Denton bought Zeon, and when he filed Chapter 11 bankruptcy two years later, a coalition of the sons of the original owners and key employees bought the business from the bank and continue to operate it today.

Working in close proximity to his father, and often stopping to ask him technical questions, Dave Pelletier serves as president. Lionel Specter sits in a comfortable corner

Figure 3.7 An example of reverse painting. Photograph by Ellen D. Babcock.

office under a well-known 1950s Ernest Haas photo of Route 66 bristling with neon signs in Albuquerque's Nob Hill.

Dave speaks of the resistance to illuminated signs that companies such as his have encountered from civic-planning entities and politicians since the mid 1970s and the detrimental effects that restrictive sign ordinances have had on local economic vitality. He blames excessive regulation for the boring and repetitive rectangularity of signs that succeeded the exuberance and whimsy of the 1940s, '50s, and '60s.

To address growing concern about light pollution and gaudy design reminiscent of Las Vegas, the city of Albuquerque passed a sign ordinance in 1976 that strictly curtailed the height and allowable square footage of commercial signs. Irregularly shaped signs had to be measured as a series of contiguous rectangles, so most businesses

commissioned simple rectangles in order to fit as much information as possible into the allowable dimensions.

The Plath brothers attribute the bland sameness they see in signs made since the 1970s to the loss of hand craftsmanship and digitization. John Plath claims that he is one of the last sign makers in town who knows how to reverse paint by hand on plastic, and a beautiful example of this technique hangs on the wall of their shop (fig. 3.7).

Both Dave Pelletier and the Plath brothers welcome the recent glimmer of new possibilities for signage in Albuquerque. Commercial, historic-preservation, and film and art projects incorporating Albuquerque's vestiges of vintage signs have been supported by recent initiatives, such as the Central Avenue Neon Design Overlay Zone initiated by current mayor Richard Berry, which allows for changes to the city's sign ordinances that will offer size and height bonuses and waive permits for enterprises that include neon in their signage (City of Albuquerque 2013).

The city council also recently passed an amendment to the public art ordinance allowing lease agreements between property owners and the city so city funding can support art projects sited in privately owned signs. These initiatives may add to the variety of sign materials and processes along Albuquerque's streets and will help bring light and color to dark and empty stretches of the mother road.

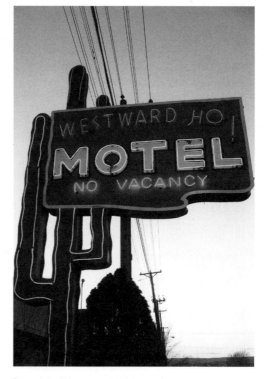

Figure 3.8 Westward Ho Motel sign, east side. This sign was recently restored. Local commercial businesses, federal and state Route 66 associations, the film and TV industry, and individual artists currently commission Zeon for neon work. Photograph by Ellen D. Babcock.

Figure 3.9 Sal Lucero, owner of a Whiting Bros. gas station in Moriarty, New Mexico, received a grant from the National Park Service Route 66 Corridor Preservation Program to help restore these two signs (see http://www. nps.gov/rt66/grnts/neonreport.pdf for a report on signs restored by this program). Zeon had to delay the restoration for months when a family of owls moved into the sign. A camera installed in the sign live-streamed their activities, and when they had safely flown the coop in late 2014, neon was installed and residents gathered at the sign for a lighting celebration. Photograph by Ellen D. Babcock.

Figure 3.10 Zeon installer inspecting a sign for repairs at Casa Barelas on south Fourth Street in 2014 for a Friends of the Orphan Signs artwork project, which will include a neon scotch border around the upper oval. Zeon originally made this gas station sign in 1960. Design drawings similar to those in this collection have informed several recent restoration and artwork projects. Photograph by Ellen D. Babcock.

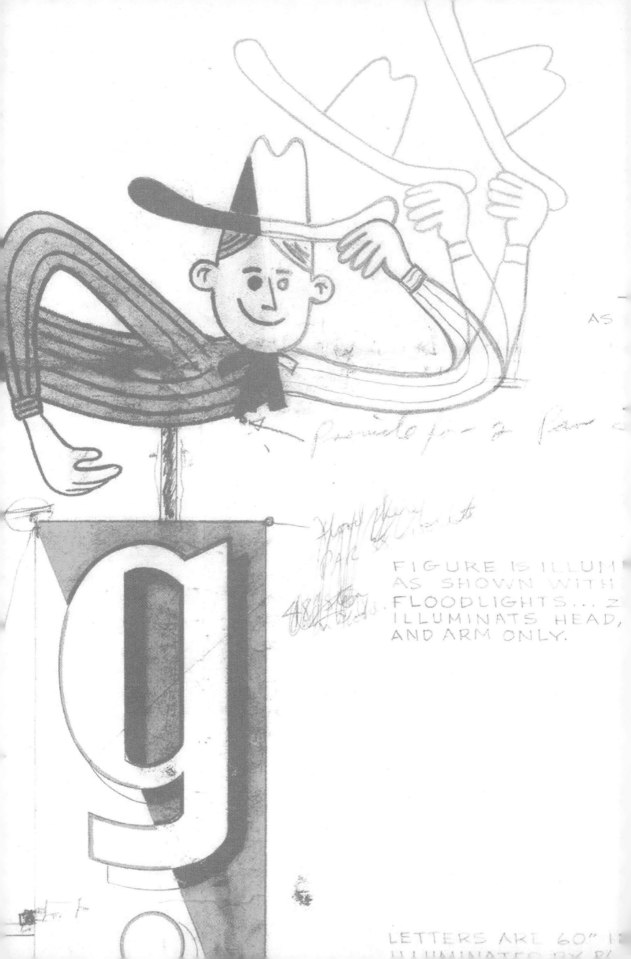

FIGURE IS ILLUM[
AS SHOWN WITH
FLOODLIGHTS... z
ILLUMINATS HEAD,
AND ARM ONLY.

LETTERS ARE 60" I[
ILLUMINATED BY P[

FOUR | *New Riffs*

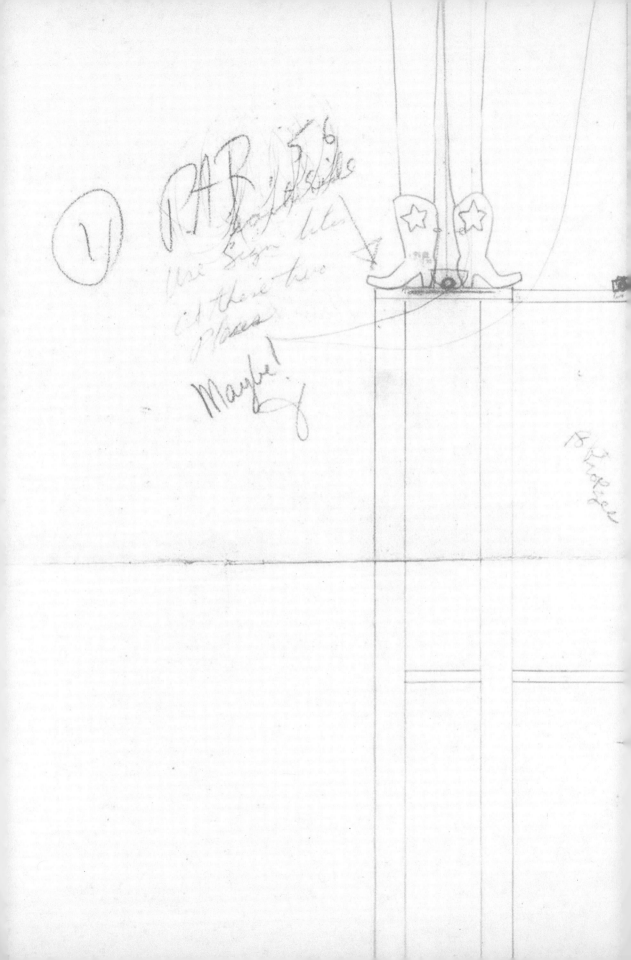

The previous chapters display the delight embodied in the commercial art of Route 66 signs. Their unused remnants—orphan signs standing boldly roadside, rusted, empty, signing the bygone past—have their own sculptural power. Many books, documentaries, and postcards have captured and commented on the spirit of these little monuments (for example Atkins 2009; Davidson 2007; Levine and Macon 2012; Margolies and Gwathmey 1993; Swan and Laufer 1994). Is this the end of the story?

Artists recast, reuse, and otherwise riff on previous work. As Andy Warhol's 1962 *Campbell's Soup Cans* illustrates, this includes appropriating commercial art. In addition to efforts to restore and preserve remaining mid-twentieth-century commercial road signs, how might we appropriate the commercial art of Route 66 signs? Can we evoke the delight that animated the signs to produce vibrant twenty-first-century art?

In Albuquerque there is an emerging practice of creating artworks that riff on the signs, their changed urban contexts, and their cultural resonances. What follows is a sketch of this emerging practice.

FRIENDS OF THE ORPHAN SIGNS

Friends of the Orphan Signs (FOS) grew out of a seminar taught by coauthor and sculptor Ellen D. Babcock at the University of New Mexico in 2009. In 2012 FOS was incorporated as a nonprofit organization to revive the skeletal remains of unused signs with the creative voices of Albuquerque. Sherri Brueggemann, director of the City of Albuquerque Public Art Urban Enhancement Program, credits FOS with starting the movement of reinhabiting unused sign structures as art and helping to revive the playful spirit that generated the original signs (personal communication). The FOS projects raised questions about the relationship between public art and commercial art, art as adaptive reuse, and a tangle of land-use and property issues.

FOS projects include:

Revivir—4119 Central Avenue NE, 2011

Led by Ellen D. Babcock, FOS members Aline Hunziker, Bethany Delahunt, and Lindsey Fromm worked intensively with Highland High School students from January to June 2012 to develop designs for an unused motel sign at 4119 Central Avenue. Forming an after-school art club, the FOS team introduced students to digital graphic-design skills, critical-thinking exercises, and exploratory field trips as part of a collaborative design development focused on this orphan sign. The backlit, neon-lined sign showcases the artwork of teens Hilary Weir, Ellie Martin, Gabe Thompson, and Desiree Marmon.

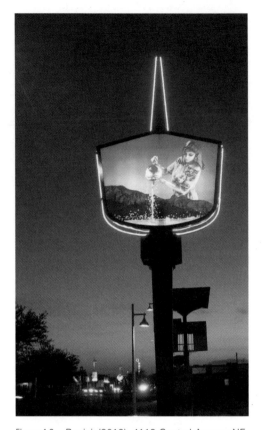

Figure 4.2 *Revivir* (2012), 4119 Central Avenue NE, by Highland High School students Hilary Weir, Ellie Martin, Gabe Thompson, and Desiree Marmon with Friends of the Orphan Signs' artists Ellen D. Babcock, Aline Hunziker, Bethany Delahunt, and Lindsey Fromm. This project received a Year in Review Award from Americans for the Arts in 2013. Photograph by Ellen D. Babcock.

Trade Winds—5400 Central Avenue SE, 2010–2014

From 2010 to 2014 FOS held a lease to three orphan signs that graced the former site of the Trade Winds Motel. FOS team members displayed text messages and images submitted by the public in response to a phone number and URL posted on the signs. In 2012, with the help of Albuquerque's Sprout micro-granting initiative, FOS rehabilitated a second sign on this site (Sprout is now A/WAY; see http://thisisaway.org/about/). In September 2012 FOS hosted a night of video projections with a theme of "lingering" onto the wall of the then-extant Octopus Carwash at the western edge of the lot to celebrate the revitalization of the third sign on the lot.

Figure 4.3 *Trade Winds*, 5400 Central Avenue SE. Between the fall of 2010 and the redevelopment of the lot in the fall of 2014, Friends of the Orphan Signs displayed messages and poems submitted by the public on the reader board of the Trade Winds sign. Photograph by Ellen D. Babcock.

Keepsake 1 of the Royal Hotel Series—4119 Central Avenue NE, 2013

The 2013 Keepsake project is one in a series of artworks that inhabit the Royal Hotel sign. *Keepsake 1* was collaboratively developed by artists Ellen D. Babcock and Billy Joe Miller working with octogenarians Ed and Lois King. On one side of the sign is a photograph of Lois King as a child in the 1930s chosen from the Kings' collection of snapshots. Babcock and Miller paired this photograph with one of a bird. On the opposite side of the sign is the artists' photograph of Lois's socks with the sky as background. This image arose from a conversation between the artists and Lois about her childhood photo.

Other projects for the Royal Hotel sign have included teens, under the guidance of artist Nani Chacon, photographing and collaboratively painting an image of a midcentury car for one side of the sign and designing a contemporary St. Christopher, patron saint of travelers, for the opposite side.

Figure 4.4a *Keepsake 1*. Photograph by Ellen D. Babcock.

Figure 4.4b Billy Joe Miller, Ellen D. Babcock, Lindsey Fromm, and Lois King staging the *Keepsake 1* photograph of Lois King's socks. Photograph by Ed King.

Figure 4.5 "Mother Road." Proposal by Mark C. Childs for neon signage on Central Avenue as it passes under I-25. Westbound lanes would have variations in multiple languages on the word "mother," and eastbound lanes would have variations on "road." Image by Mark C. Childs.

These projects are digital prints on sign-banner material. They are inexpensive to produce and install and are meant to be displayed for a few months.

CITY OF ALBUQUERQUE PUBLIC ART PROGRAM

The City of Albuquerque passed the Art in Municipal Places Ordinance in 1978 (http://www.cabq.gov/culturalservices/public-art), making the city an early adopter of this now-widespread approach to funding municipal art. As of 2013 there were more than five hundred pieces in the program's collection (many can be seen at http://www.flickr.com/photos/abqpublicart/).

In the twentieth century Albuquerque's Public Art Urban Enhancement Program developed projects that played on the Route 66–era commercial signs including the Nob Hill Gateways (1993) by Terry Conrad and Joan Weissman and the 1997 neon signs for the bus stop at Triangle Park by Joan Weissman.

Recently the Public Art Urban Enhancement Program supported FOS projects and initiated a set of its own projects. The on-call neon artists program (started in 2013) aims to develop custom designs that businesses could use for new signs (fig. 4.5). The Sundowner Sign Reuse Project centered on reuse of a skeletal sign in front of the Route 66–era Sundowner Motel. The Sundowner was reportedly home to Microsoft founders Bill Gates and Paul Allen in the mid-1970s. The motel was recently adapted into a housing project by New Life Homes. The call for proposals asked for light-based artwork (figs. 4.6, 4.7, 4.8).

As a consequence of the FOS and Sundowner projects, the Public Art Urban Enhancement Program, city lawyers, and city policy makers have sought methods to navigate a complicated knot of property, copyright, and land-use law. When and in what ways is a sign structure unused? Does adding temporary art to the structure affect its legal status as a historic sign?

Figure 4.6 "Sundowner" proposal by Suzanne Clem-Wheeler, 6101 Central Avenue NE. The artist writes, "The design for the Route 66 sign was inspired by both the descriptive Sundowner name and programmable LED technology that can change the colors of a beautiful sunset, evolving so that the art is visually a different collection of hues each time it is seen throughout a day." See www.suzanneclemwheeler.com for more of her work. Project funded by the City of Albuquerque Public Art Urban Enhancement Program, 2014–2015. Image courtesy of Suzanne Clem-Wheeler.

Figure 4.7 "Sundowner" proposal by Alejandro P. Siña with Moira Siña, Constanza Castaño, and Carlos Garin. See www.sinalightworks.com for more of their work. Image courtesy of Alejandro P. Siña.

Lighting & Technology

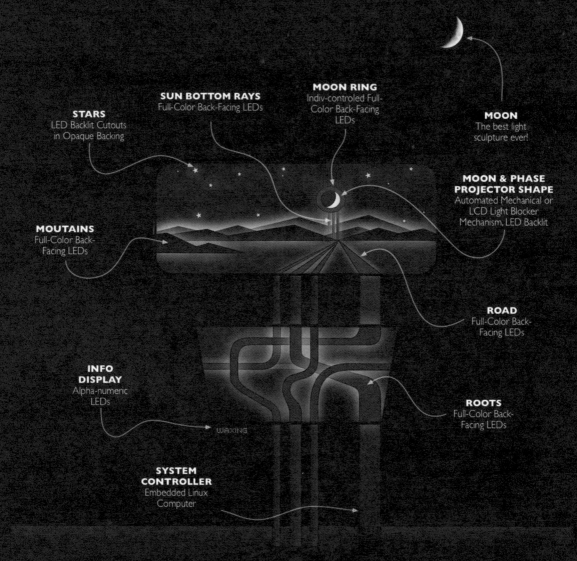

STARS
LED Backlit Cutouts
in Opaque Backing

SUN BOTTOM RAYS
Full-Color Back-Facing LEDs

MOON RING
Indiv-controled Full-
Color Back-Facing
LEDs

MOON
The best light
sculpture ever!

**MOON & PHASE
PROJECTOR SHAPE**
Automated Mechanical or
LCD Light Blocker
Mechanism, LED Backlit

MOUTAINS
Full-Color Back-
Facing LEDs

ROAD
Full-Color Back-
Facing LEDs

**INFO
DISPLAY**
Alpha-numeric
LEDs

ROOTS
Full-Color Back-
Facing LEDs

WAXING

**SYSTEM
CONTROLLER**
Embedded Linux
Computer

Figure 4.8 "Sundowner" proposal by Dave Loomis.
More of Dave Loomis's work can be seen at http://
lumieria.com. Image courtesy of Dave Loomis.

What exactly is a sign? When is a project art? Is public art a land use? In December 2014 the Albuquerque City Council passed an ordinance that helped untangle this knot and allows the city to lease private signs to place public art on them (File #0-14-31).

CITY OF ALBUQUERQUE PLANNING DEPARTMENT

In June 2013 the City of Albuquerque adopted the Central Avenue Neon Design Overlay Zone (CAN DOZ) "to develop Route 66/Central Avenue as a distinct district through the use of historic sign types that bring a sense of delight and vibrancy to the streetscape. . . . Design can be 'retro,' contemporary or futuristic" (City of Albuquerque 2013).

The intent of CAN DOZ is to help (re-) create a "great neon way" that capitalizes on Albuquerque's Route 66–era heritage and creates a modern commercial destination. The city adopted CAN DOZ following current theories that public art can serve as a revitalization tool. The funding collaborative ArtPlace America, for example, claims that "arts-related activity plays a key role in contributing to the kind of quality of place that attracts and retains talented people and enables people to put all of their talent to work. These kinds of flourishing places generate additional innovation and economic activity" (www.art placeamerica.org). ArtPlace has developed a set of "vibrancy indicators" to attempt to measure this claim.

SCHOOL OF ARCHITECTURE AND PLANNING, UNIVERSITY OF NEW MEXICO

The School of Architecture and Planning at the University of New Mexico has also explored the potential for a sign-art district.

Architecture studio projects studying the adaptive reuse of Route 66 motels, for example, included adaptive reuse of their signage, and landscape architecture studios have explored incorporating Route 66–inspired art in the redesign of streetscapes and parking lots. More directly, students in coauthor Mark C. Childs's Civic Space course have proposed designs for projects under consideration by the Albuquerque Public Art Program such as the Gateway Signs Project. This project proposes placing artwork near the east and west ends of Central Avenue as symbolic entrances to Albuquerque.

These academic studies explore the potential and pitfalls of projects prior to a public call for designs, illustrate new possibilities, and help a new generation of architects see signage and public art as part of their toolkit for the creation of great places.

AN EMERGING PRACTICE

The art/sign practice is just emerging and has not yet found the range of its potential. Albuquerque Public Art Urban Enhancement Program Director Sherri Brueggemann believes the adaptive reuse of orphan signs and the creation of new art riffs on Route 66 signage can be "a stable, ongoing current of who we are as a city" (personal communication). However, this art practice could flourish in many places, from Paris where the neon sign first appeared; to the cities, burgs, and one-pump towns of Route 66; to the Australian Outback where officials are considering renaming a highway "Route 66" ("Get Your Kicks on Australia's Route 66," *Wall Street Journal*, February 24, 2014).

The practice presents opportunities to play with nostalgia and history, boom and bust, with commercial art versus high art,

with kitsch and mash-ups, the cult of the automobile and the open road, with the meanings of signing and signage, and much more. The urban-design potential includes creating entrances, landmarks, and districts. Classic urban design literature suggests creating "street walls" with a continuous line of buildings facing the sidewalk to enclose and shape the space of the street. Perhaps signage, art, and other street furniture can create a "street palisade" to define the space of the street. More importantly, this work may foster a dialogue, both verbal and through built projects, about the character and roles of the public realm of the street.

The art/sign practice could be encouraged by establishing a clear legal framework, a body of patrons and critics, workshops or forums for artists, builders, and owners, and "gallery" mechanisms such as trolley or cell-phone tours.

We write this as participants, instigators, and advocates for a revival and elaboration of the spirit of play embodied in twentieth-century signs. We aim to foster a second act that reexamines, enriches, rewrites, and explores the nuances and complications of the twentieth century's first act. We hope this book will provide inspiration to a new era of artists, architects, planners, and business owners.

Figure 4.9 Proposal for the East Gateway to Central Avenue by Mojdeh Azaddisfany. Image courtesy of Mojdeh Azaddisfany.

Figure 4.10 (opposite page) Proposal for the West Gateway to Central Avenue by Hanquing Kuang. Image courtesy of Hanquing Kuang.

INSTALLATION / SERVICE RECEIPT

ZEON SIGNS

2020 5th N.W. ALBUQUERQUE, N.M.

Name _Discount Furniture_

Address _5411 Lomas N.E._

(City) _____

Date _4-27-67_

ELECTRICAL PRODUCTS CO. OF N.M.

Repaired A _revamp_ _____ Sign

Installed A _all signs on_ Sign

Checked A _AL-4408_ _____ Sign

FOR US. THIS SIGN IS IN THE EXACT LOCATION
WE REQUESTED AND IS TO OUR SATISFACTION.

Signed _Lena_ _____

Workman _C.E. Dye_ _____

References

Atkins, Rob. 2009. *Neon Mesa: Wonders of the Southwest*. Piermont, NH: Bunker Hill Publishing Inc.

Bloom, Ken. 2003. *Broadway: Its History, People, and Places: An Encyclopedia*. 2nd ed. New York: Routledge.

Bridgman Collaborative Architecture. 2010. *Neon District Feasibility Study*. http://www.bridgmancollaborative.ca/neon-district-feasibility-study.html.

Childs, Mark C. 1996. "The Incarnations of Central Avenue." *Journal of Urban Design* 1 (2): 281–98.

Childs, Mark C. 2012. *Urban Composition: Designing Community through Urban Design*. New York: Princeton Architectural Press.

City of Albuquerque, New Mexico. 2013. Central Avenue Neon Sign Design Overlay Zone. Council Bill No. R-13-165. http://www.cabq.gov/planning/documents/CANDOZFina1062413.pdf.

City of Portland, Oregon. 2008. *North Interstate Corridor Plan*. Ordinance No. 182072. http://www.portlandoregon.gov/bps/article/208321.

Davidson, Len. 2007. *Vintage Neon*. Atglen, PA: Schiffer Publishing.

Ephemeral New York (blog). 2012. "The Broadway Electric Billboard That Started It All." November 29, 2012. http://ephemeralnewyork.wordpress.com/2012/11/29/the-broadway-electric-billboard-that-started-it-all/.

Levine, Faythe, and Sam Macon. 2012. *Sign Painters*. New York: Princeton Architectural Press.

Margolies, John, and Emily Margolin Gwathmey. 1993. *Signs of Our Time*. New York: Abbeville Press.

Nye, David E. 1990. *Electrifying America: Social Meanings of a New Technology, 1880–1940*. Cambridge, MA: MIT Press.

Ribbat, Christoph. 2013. *Flickering Light: A History of Neon*. London: Reaktion Books.

Sennett, Richard. 2008. *The Craftsman*. New Haven, CT: Yale University Press.

Swan, Sheila, and Peter Laufer. 1994. *Neon Nevada*. Reno: University of Nevada Press.

Treu, Martin. 2012. *Signs, Streets, and Storefronts: A History of Architecture and Graphics along America's Commercial Corridors*. Baltimore, MD: Johns Hopkins University Press.

Contributors

Ellen D. Babcock draws inspiration from vestiges of the past uncovered in urban landscapes and from a panoply of materials, often scavenged or reused, for her sculptures, installations, public art events, and writings. She has exhibited at numerous New Mexico and California venues, including the New Mexico Museum of Art in Santa Fe and the San Francisco Arts Commission Gallery and Southern Exposure in San Francisco. Ellen worked as a sculpture technician and materials researcher with Art Foundry in Santa Fe, New Mexico, from 1985 to 1999. She became an assistant professor of sculpture at the University of New Mexico in Albuquerque in 2009, and in the same year she founded Friends of the Orphan Signs (FOS), an organization that sites collaboratively produced public art in abandoned signage. Since 2009 FOS has created numerous public artworks and events and has received funding from the National Endowment for the Arts, the McCune Foundation, and the Black Rock Arts Foundation. The FOS project *Revivir*, a neon sign/artwork, received the Year in Review Award from Americans for the Arts in 2013.

Mark C. Childs works across disciplines, roles, and administrative structures to support the emergence of soul-enlivening, resilient, healthy, and environmentally sound communities. He is the associate dean and a professor at the School of Architecture and Planning, University of New Mexico. Mark is the author of *Urban Composition: Developing Community through Design* (EDRA Award winner 2013), *Squares: A Public Place Design Guide for Urbanists* (Planetizen Top Ten Books 2005), and *Parking Spaces: A Design, Implementation, and Use Manual for Architects, Planners, and Engineers* and has lectured widely on these topics. He is a Fulbright Scholar (Cyprus 2005) and has won awards for community engagement, teaching, public art, heritage preservation, and poetry.